P9-CEF-318

Pub.
18.99

The Postcard History Series

Salem

IN Vintage Postcards

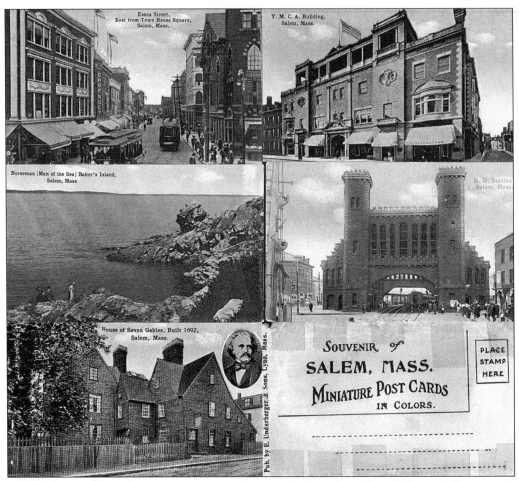

Essex Street,
East from Town House Square,
Salem, Mass.

Y. M. C. A. Building,
Salem, Mass.

Norseman (Man of the Sea) Baker's Island,
Salem, Mass.

R. R. Station
Salem, Mass.

House of Seven Gables, Built 1692,
Salem, Mass.

Pub. by E. Underberger & Sons, Lynn, Mass.

SOUVENIR of
SALEM, MASS.
MINIATURE POST CARDS
IN COLORS.

PLACE
STAMP
HERE

This is part of a fine miniature souvenir card set in which each card could be mailed separately or together in an envelope provided. This set was produced before 1901 when postcard sizes became fairly standardized.

THE POSTCARD HISTORY SERIES

Salem

IN VINTAGE POSTCARDS

Christopher R. Mathias, Michel D. Michaud, and Kenneth C. Turino

ARCADIA

Copyright © 1999 by Christopher R. Mathias, D. Michel Michaud, and Kenneth C. Turino.
ISBN 0-7385-0330-4

Published by Arcadia Publishing,
an imprint of Tempus Publishing, Inc.
2 Cumberland Street
Charleston, SC 29401

Printed in Great Britain.

Library of Congress Catalog Card Number: Applied for.

For all general information contact Arcadia Publishing at:
Telephone 843-853-2070
Fax 843-853-0044
E-Mail arcadia@charleston.net

For customer service and orders:
Toll-Free 1-888-313-BOOK

Visit us on the internet at http://www.arcadiaimages.com

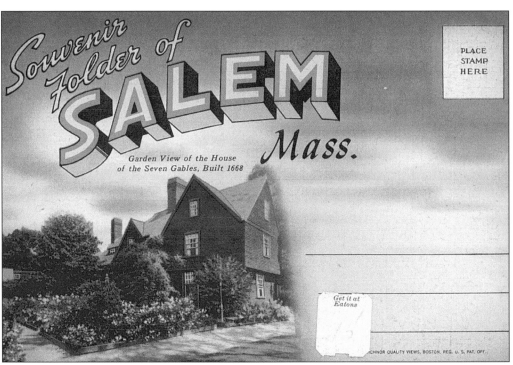

While not individual postcards, souvenir folders continue to be popular. This linen set, sold at Eaton's Apothecary, contains 14 images of historic and picturesque sites of the city, all the size of standard postcards.

974.4
SAlem
M

247
3226

18.99

CONTENTS

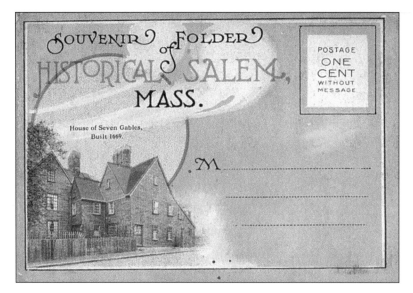

Miniature folder sets were popular keepsakes and were often sent as postcards to relations or friends. This early set contained 20 historical images.

ACKNOWLEDGMENTS

The authors wish to thank Nelson Dionne for generously lending postcards from his outstanding collection, one of the finest of Salem, Massachusetts. His contributions brought many unique images to this publication. Thanks also to John M. Kobuszewski for his encouragement with this project, and to Diane Shephard for providing excellent editorial assistance as well as typing the manuscript. Unless noted otherwise, the postcards are from the collection of D. Michel Michaud.

INTRODUCTION

Collecting postcards is a popular activity that began in what is considered the "Golden Age of Postcards" (1897–1917). At that time, collecting and viewing collections were popular passions that more recently have surged again, particularly with the renewed interest in photography and ephemera (printed material designed for a short time span such as tickets or programs). Before the widespread use of personal cameras, postcards frequently offered a unique view of our world, setting it in time and place. Postcards are in many cases the only remaining images we have of buildings, stores, houses, people, etc. The images selected for this publication on Salem, Massachusetts, are drawn from two major private collections. They include many rare views and show us the changes over time that have affected the city from before the turn of the 20th century right up to the beginning of the 21st.

The history of postcards dates to 1869, when the Austrian government issued the first one—a yellow, 2 kreuzer stamp imprinted on the upper right hand corner with three ruled lines for the address. The message was written on the back. The popularity of this easy and inexpensive form of communication soared. In 1873, the United States government followed with pre-stamped postal cards, and the Americans' love of these cards began. The Columbian Exposition of 1893 in Chicago was the first fair in America to use privately printed picture postal cards as souvenirs; these are highly desirable today. The cards were government-issued until 1898, when Congress passed an act allowing private publishers the right to produce them. These cards, in use until 1902, had to be inscribed "Private Mailing Card" and writing messages was not permitted on the address side. The earliest cards in this book date from this period. From 1907, divided backs (one half for the address, the other for the message) were in general use. Many early cards were printed in Germany, but with the coming of World War I more and more Americans entered the business. Although there was an abundance of Salem postcards printed in line with its growth as a tourist destination and a shopping center, most cards were published and printed outside of the area. Very little is known about postcard publishers at this time. One Salem publisher, Calixte Rousseau (1863–1909) was a French-Canadian immigrant who opened a variety store on Harbor Street in 1896. He published and sold several full-backed picture postcards of different views of Salem, examples of which are included in this book.

The authors have brought together a variety of postcard types beside those from the "Golden Age." Linen cards produced from the 1920s through the 1950s are included. These distinctive cards have a linen-like finish and were produced in intensified colors. Many of the more recent cards from 1939 on are called "chromes" and were produced from color film.

The postcards presented here capture the spirit of Salem, its people, neighborhoods and homes, places of worship and amusement, and especially the Willows. Salem's tourist industry dates back over a century, and many cards were produced to promote the historic buildings and museums that are an integral part of the fiber of the city. Numerous novelty cards were produced for "The Witch City" as well as advertising cards manufactured for the businesses in this thriving retail center. In short, these postcards offer a unique view of this historic city.

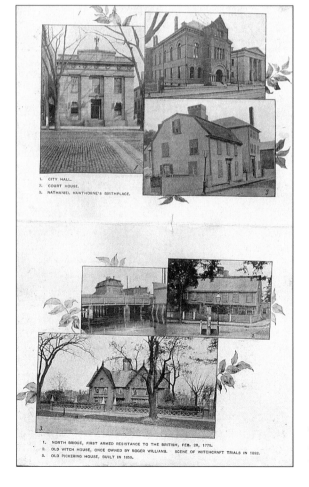

1. CITY HALL.
2. COURT HOUSE.
3. NATHANIEL HAWTHORNE'S BIRTHPLACE.

1. NORTH BRIDGE, FIRST ARMED RESISTANCE TO THE BRITISH, FEB. 26, 1775.
2. OLD WITCH HOUSE, ONCE OWNED BY ROGER WILLIAMS. SCENE OF WITCHCRAFT TRIALS IN 1692.
3. OLD PICKERING HOUSE, BUILT IN 1650.

This folding souvenir postcard from 1902 was sent without a written message.

One
WELCOME TO SALEM

Although this postcard with "Salem" printed on the pennant could be a scene from the Willows, it is actually a generic card. Generic cards were popular postcards that allowed a printer to use one design in many markets.

The sheer number of novelty and souvenir postcards featuring Salem attests to its popularity as a destination at the turn of the century. This card dates from 1907.

Novelty postcards often had an amusing scene printed on the front with a witty statement. The sender of this card, a North Shore tourist, wrote in August 1912, ". . .came up here in a touring car. . .one great ride."

A strikingly modern design for its time adorns this postcard, reinterpreting the popular witch theme.

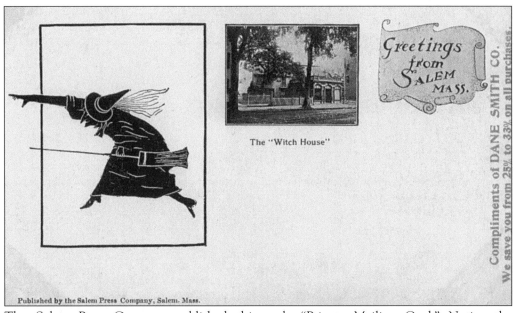

The Salem Press Company published this early "Private Mailing Card." Notice the advertisement for Dane Smith Company, a department store (1904–1906) located at 277-279-281 Essex Street. The Witch House, actually the Jonathan Corwin House, is shown with an attached drugstore.

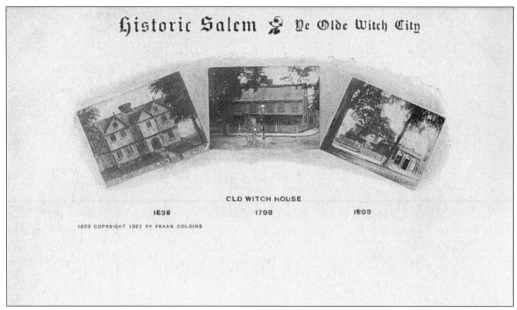

CLD WITCH HOUSE

1698 1798 1898

1809 COPYRIGHT 1902 BY FRANK COUSINS

Frank Cousins published this greeting card in 1902. It depicts three views of the Jonathan Corwin House, popularly known as the Witch House. The first view is an interpretation of what the house may have looked like in the 17th century. The center image is actually a mid-19th century photograph, and the last view shows an unrestored house c. 1898 with a drugstore attached to the east front. Cousins was the premier Salem photographer.

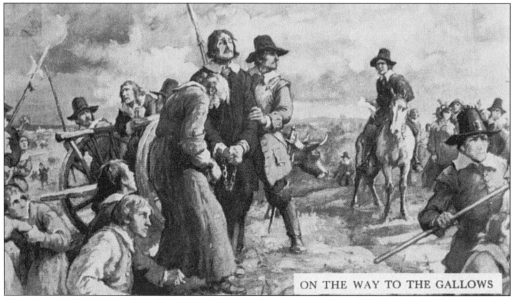

ON THE WAY TO THE GALLOWS

This is one of a series of cards depicting scenes from the witchcraft hysteria of 1692. The card shows four of the five victims of August 19, 1692. The Reverend George Burroughs is portrayed in his clerical attire and to the left of Burroughs, hands in chains, is John Proctor. In the ox cart are George Jacobs and John Willard.

12

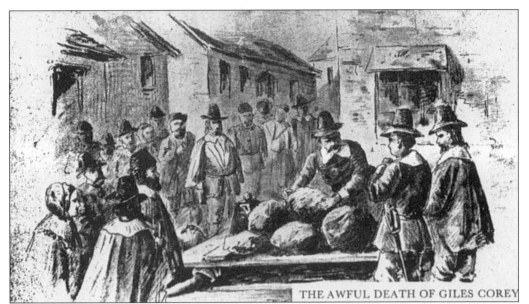

THE AWFUL DEATH OF GILES COREY

The Pilgrim Motel, 40 Bridge Street, printed these two cards and that of the preceding page as part of a series for their guests. The top card illustrates the gruesome death of Giles Corey, the only person accused of witchcraft to be pressed to death. The bottom card shows a group of children listening to Tituba, the Jamaican slave of Rev. Samuel Parris, speak of witchcraft.

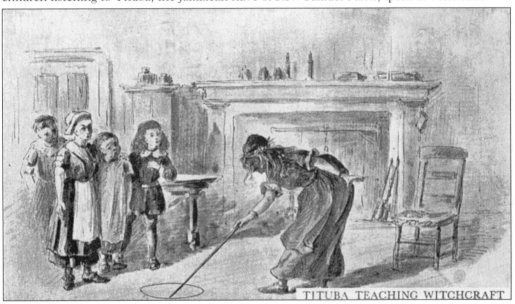

TITUBA TEACHING WITCHCRAFT

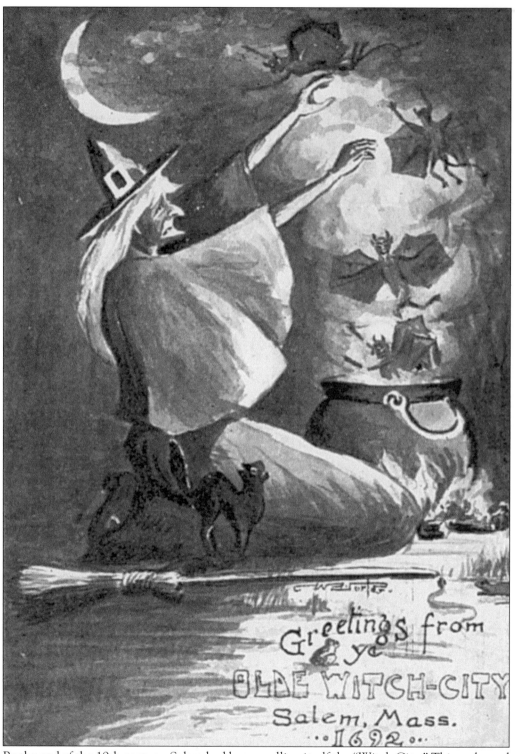

Greetings from
& ye
OLDE WITCH-CITY
Salem, Mass.
··1692··

By the end of the 19th century, Salem had begun calling itself the "Witch City." This early card was privately printed for W.B. Porter in 1905.

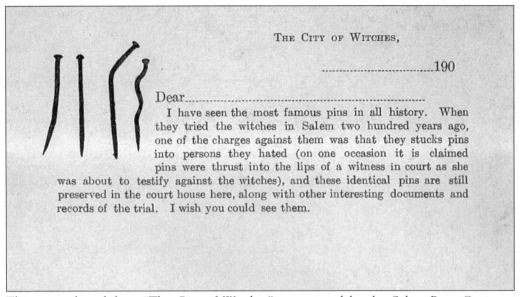

.....................................190

Dear...

I have seen the most famous pins in all history. When they tried the witches in Salem two hundred years ago, one of the charges against them was that they stucks pins into persons they hated (on one occasion it is claimed pins were thrust into the lips of a witness in court as she was about to testify against the witches), and these identical pins are still preserved in the court house here, along with other interesting documents and records of the trial. I wish you could see them.

This unusual card from "The City of Witches" was printed by the Salem Press Company between 1901 and 1907. The card tells an interesting, although false, story regarding the "witch pins." Preserved with the witch trial papers, the pins are often found in court records of the period and were used to hold papers together.

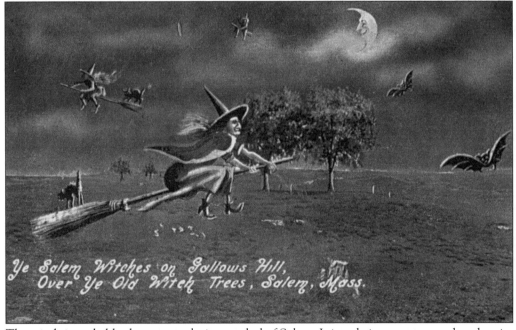

Ye Salem Witches on Gallows Hill, Over Ye Old Witch Trees, Salem, Mass.

The witch is probably the most enduring symbol of Salem. It is only in recent years that the city has tried to broaden its image.

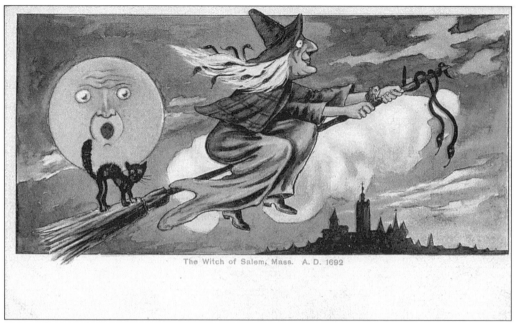

The Witch of Salem, Mass. A. D. 1692

An early card, (1898–1907) this scene of a witch includes the most commonly associated images: a black cat riding a broomstick with a witch, and the moon.

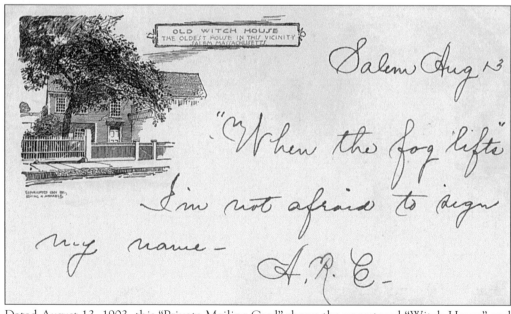

OLD WITCH HOUSE
THE OLDEST HOUSE IN THIS VICINITY
SALEM MASSACHUSETTS

Salem Aug 13

"When the fog lifts" I'm not afraid to sign my name — A. R. C. —

Dated August 13, 1903, this "Private Mailing Card" shows the unrestored "Witch House" and includes a frightful statement.

Two
PEOPLE AND PLACES

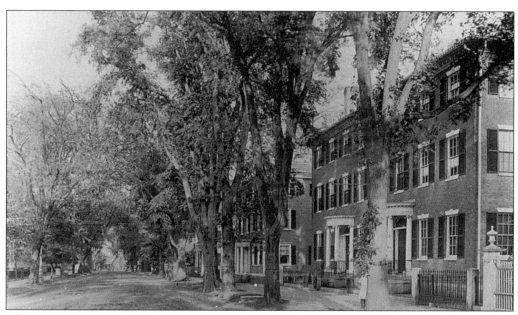

Chestnut Street was laid out in 1796, and is a textbook example of fine urban planning. Originally designed to be 40 feet wide, it was increased to an elegant 80 feet in 1804. On the right is the Pickering-Mack-Stone double house at 21-23 Chestnut Street. It was built in 1814 in the popular Federal style, as are most of the other houses on the street.

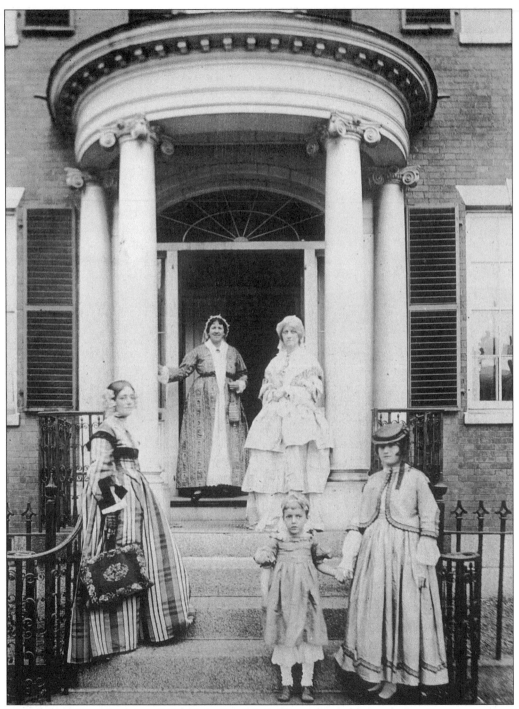

The elegant front doorway of the Pickering-Mack-Stone House is the setting for this group of enthusiasts for Chestnut Street Days. People who enjoyed costumes could dress the part and stroll the street, remembering the glory days of sea captains and merchant explorers. Chestnut Street Days is an event dating back to 1926 that attempts to recreate the atmosphere of Salem's heyday as a maritime center.

18

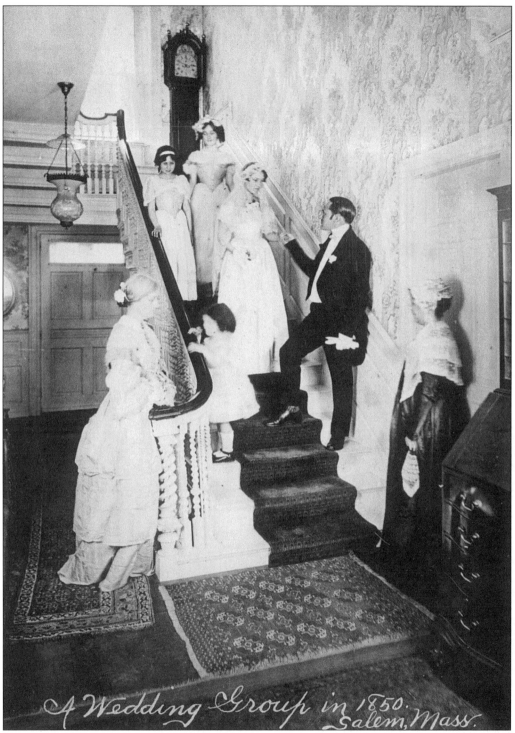

A Wedding Group in 1850. Salem, Mass.

People also posed for thematic photographs during Chestnut Street Days. This one recreated a "Wedding Group in 1850" to show off the wealth of costumes. This interior is the elegant stair hall of the Cabot-Endicott-Low House at 365 Essex Street.

Washington Square North, bordering Salem Common, presents some of Salem's finest Federal-style mansions, all built in the second decade of the 19th century. Shown here are, from left to right: the Forrester-Peabody House of 1818–19, the White-Lord House *c.* 1811, and the White-Silsbee/Hodges-Mott double house *c.* 1811–12.

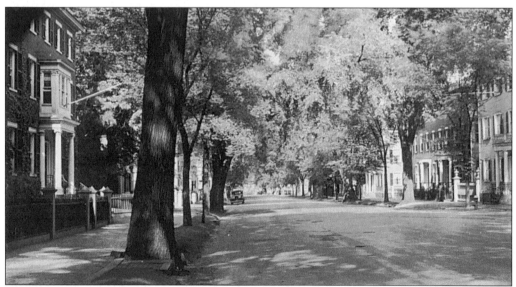

Looking east on Chestnut Street, mature trees shade the sidewalks and roadways highlight the area's gracious character. On the left is the Devereux-Hoffman-Simpson House at number 26; it was built in 1826. The Dodge-Barstow-West House, at number 25, is on the right. It was built *c.* 1802 at the corner of Pickering Street.

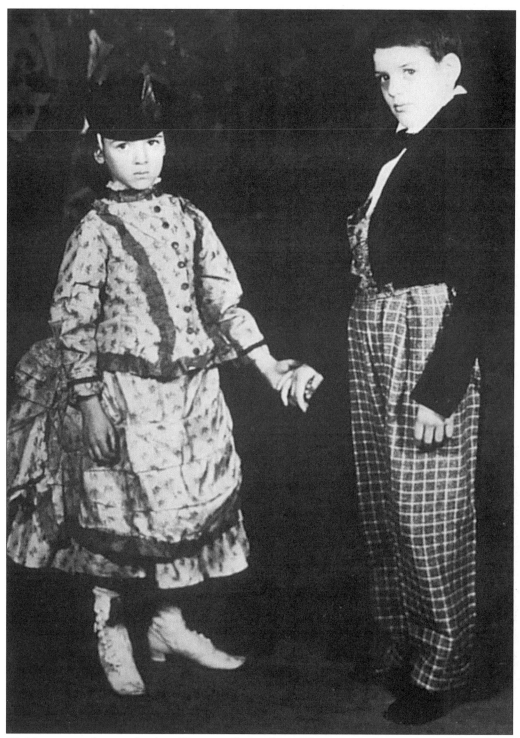

Children were also involved in Chestnut Street Days. The costumed event helped them learn about the history of Salem and their own heritage. Judging from this card, these two considered it more homework than play.

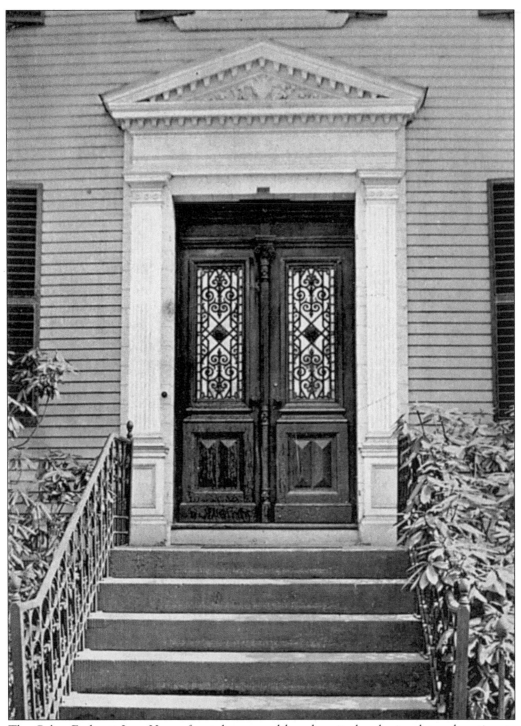

The Cabot-Endicott-Low House front doorway, although quite lovely, is a later alteration to the largely intact structure built around 1744–48. Constructed for merchant Joseph Cabot at Essex Street, it passed to William C. Endicott, a Massachusetts Supreme Judicial Court Justice, in 1870. Retailer Daniel Low lived here from 1894 to 1919.

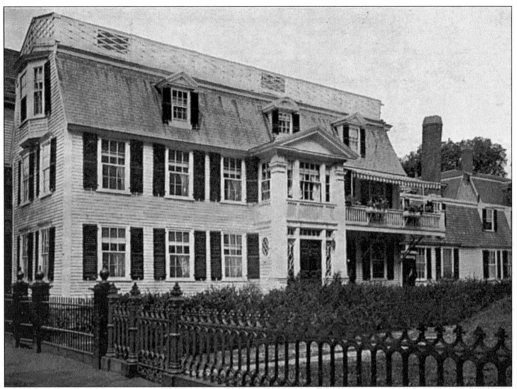

This imposing house at 362 Essex Street was built for John Ropes, a cordwainer, by 1754. Emery Johnson occupied it in 1912.

A simple Greek revival house at 23 Walter Street was the birthplace of Alpheus C. Locke, who was born in 1823. He and his brother Nathaniel C. Locke owned Locke Brothers, located at 76 North Street, which produced steam and water regulators.

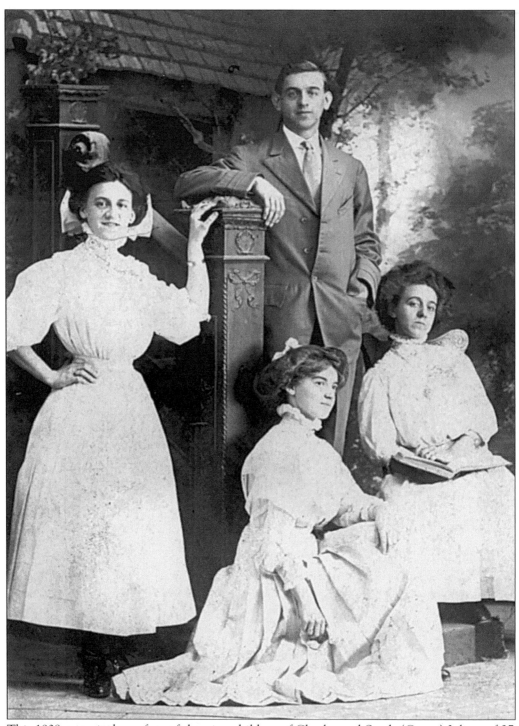

This 1908 portrait shows four of the nine children of Charles and Sarah (Caron) Julien, of 27 Harbor Street. Standing are Evelina St. Pierre (1891–1978) and Wilfred Julien (1888–1962). Seated on the left is Eglantine Thomas (1886–1967), and on the right is Alice Bourgouin (1884–1957).

Presbytere St. Joseph was the rectory for St. Joseph's parish, which served one of the French communities of Salem. This rare postcard documents a very short-lived but imposing building. Both the church and this rectory were built in 1913, only to be obliterated by the Fire of 1914. (Courtesy Nelson Dionne.)

A 1908 view, east of Lafayette Street looking down Leach Street, shows the area in its prime. The Fire of 1914 destroyed everything shown here. (Courtesy Nelson Dionne.)

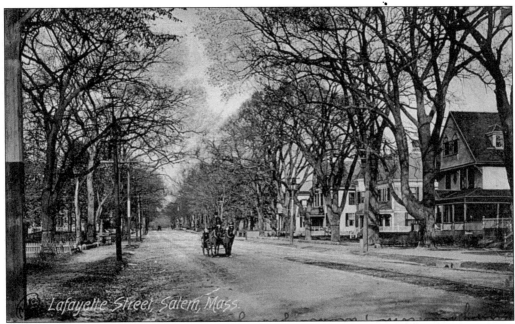

Lafayette Street, Salem, Mass.

Another well-laid-out street is Lafayette. This elegant 1907 view, taken before too many cars invaded the area, exhibits its appeal. It was called the "Champs Elysees" of Salem because of the many Second Empire-style (a style popularized in France) houses built here. The whole area was destroyed in the Fire of 1914.

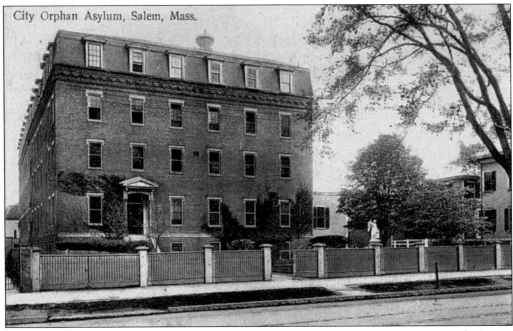

City Orphan Asylum, Salem, Mass.

The City Orphan Asylum was located at 215-219 Lafayette Street, near Hancock Street. The building, a gift of Thomas Looby, was dedicated in 1875 and was staffed by the Grey Nuns of Montreal. It was destroyed in the Fire of 1914.

Arthur William Foote, the son of the editor of the *Salem Gazette*, was born in Salem on March 5, 1853. In 1875, Harvard University awarded him with the first A.M. degree in music to be given in the United States. A founder and president of the American Guild of Organists, Foote died in Boston on April 8, 1937.

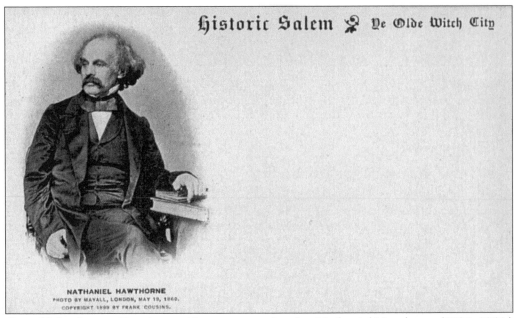

NATHANIEL HAWTHORNE
PHOTO BY MAYALL, LONDON, MAY 19, 1860.
COPYRIGHT 1899 BY FRANK COUSINS.

One of Salem's most illustrious residents was noted author Nathaniel Hawthorne (1804–1864.) This portrait photo was taken in 1860 by Mayall of London and used in this postcard by Frank Cousins in 1899.

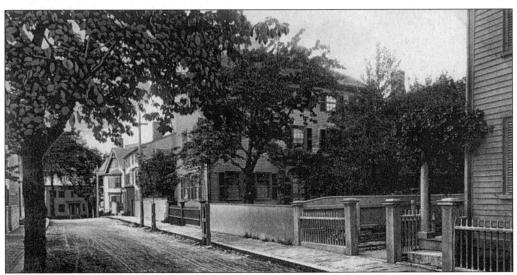

Nathaniel Hawthorne lived in the house at 14 Mall Street from 1847 until he moved to Lenox, Massachusetts, in 1850. He wrote *The Scarlet Letter* in the third floor study and, only after much cajoling, gave it to Boston publisher James T. Fields in 1850.

Candidates for office used postcards as an advertising medium. Henry A. Henfield was just one such candidate when he had this card printed in 1908.

The Reverend J. Emile Dupont, born in Salem July 8, 1889, is shown on this portrait postcard. Ordained in Boston in 1915, his first assignment was at St. Anne's Roman Catholic Church on Jefferson Avenue from 1915 to 1918.

Three
PLACES OF WORSHIP

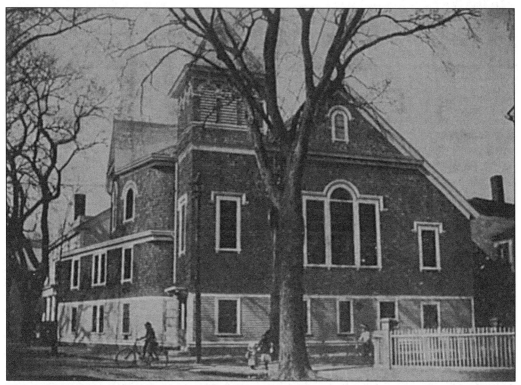

The Calvary Baptist Church was established in 1870. The congregation dedicated this building in 1904. In 1927, the Baptists moved to the former South Congregational Church on Chestnut Street. Since that date, St. John's Ukrainian Church has been located here at 124 Bridge Street and the corner of Lemon Street.

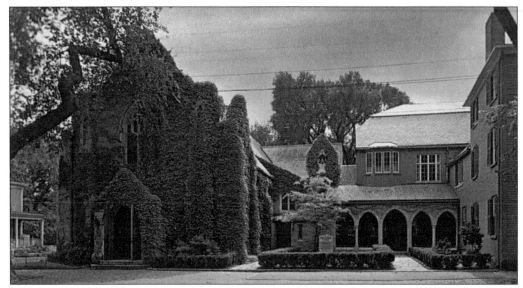

The present Grace Episcopal Church at 385 Essex replaced an earlier wooden structure. Architects Philip Horton Smith and Edgar Walker of Salem designed it in the late English Gothic Revival style in 1927. It contains four stained-glass windows from the original structure, including two by Tiffany. The parish house can be seen on the extreme right of the photograph.

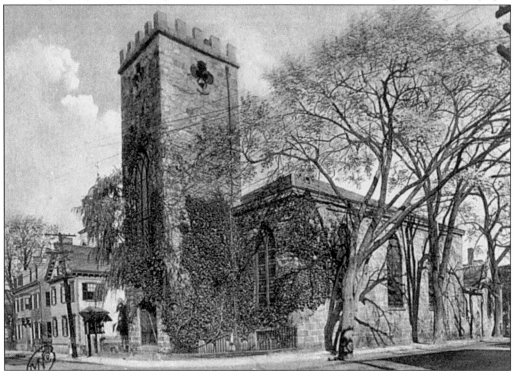

Historian Bryant F. Tolles Jr. describes St. Peter's Episcopal Church as a "ruggedly picturesque, rubble-granite masonry, Gothic Revival Church" as well as "one of the most outstanding ecclesiastical structures of its style and type in the United States." Erected in 1833–34, the building has been enlarged several times.

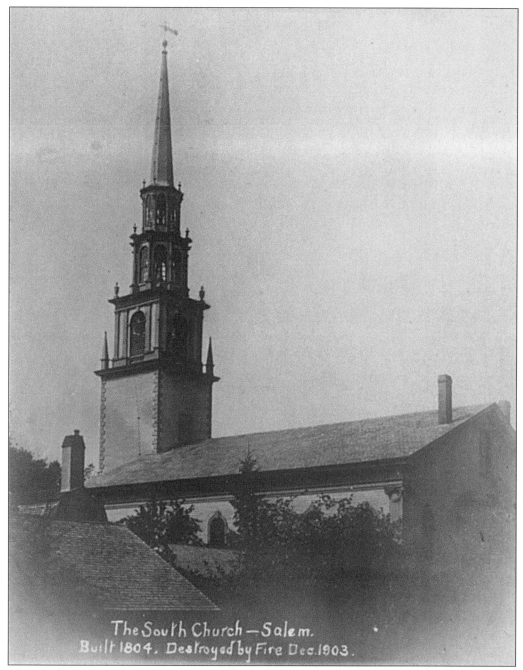

The South Church — Salem.
Built 1804. Destroyed by Fire Dec. 1903.

The South Congregational Church at Chestnut and Cambridge Street, was built in 1804 to the design of noted Salem architect Samuel McIntire. On December 20, 1903, a devastating fire consumed the church.

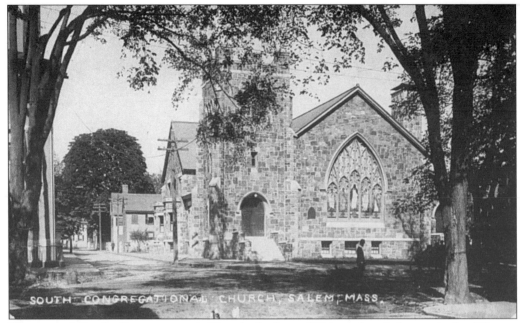

The second South Congregational Church, built in 1904, replaced the original edifice at Chestnut and Cambridge Street. The congregation reunited with the Tabernacle Church in 1923, and the building was subsequently sold to the Calvary Baptists, who occupied it until 1950. The building was razed two years later.

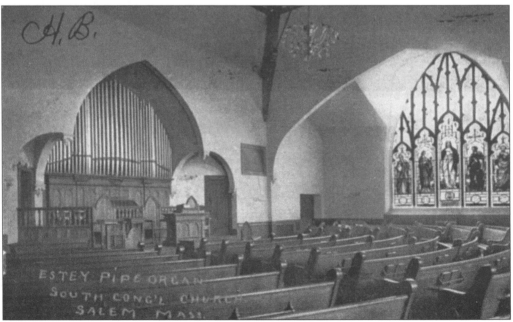

An interior view of the second South Congregational Church in 1909 shows the Estey pipe organ.

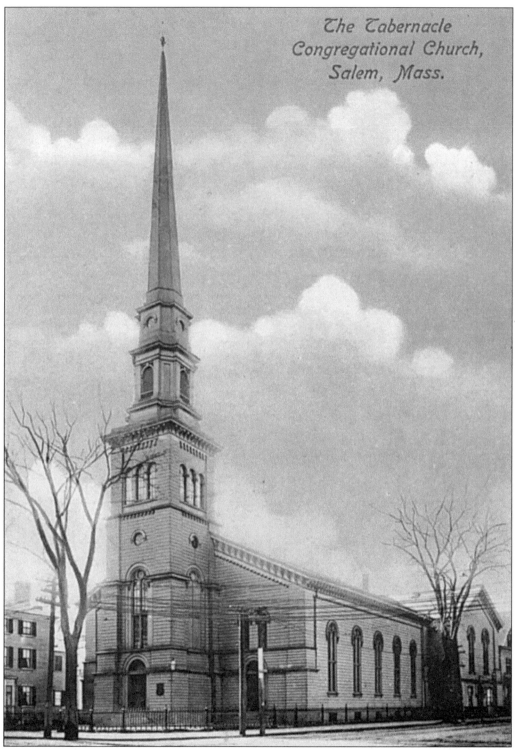

The Tabernacle Congregational Church, Salem, Mass.

The Tabernacle Congregational Church at Washington and Federal Streets was built in 1854. The building was razed in 1922 when the present building was constructed on this site.

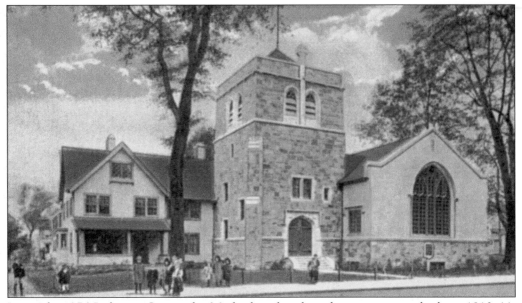

Located at 276 Lafayette Street, the Methodist church and parsonage was built in 1910–11. Recently, two Pentecostal churches, Ministerios Conquista Assembly of God Church and the Christian Renewal Church, bought the building for their own use. A third church, the North Shore Rock, a Charismatic congregation, also holds services in the building.

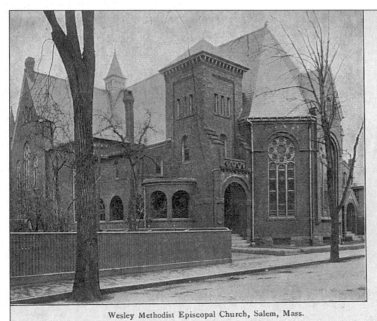

Wesley Methodist Episcopal Church, Salem, Mass.

Dear Friend:

We shall observe Sunday, October 22 as

Rally Sunday

in our Sunday School. We earnestly wish to have present on that day every person whose name is now upon our rolls, or who has formerly been a member of the School. Parents and friends are especially invited. The exercises begin at noon and will be of unusual interest.

We hope you will come and bring someone with you.

Yours cordially,

Matthew Robson,
Superintendent.

Wilbur N. Mason,
Pastor.

The Wesley Methodist Church at 8 North Street was built in 1888, and designed in the Romanesque Revival style by architect Lawrence B. Valk of New York. The "Rally Sunday" mentioned on the card took place October 22, 1905.

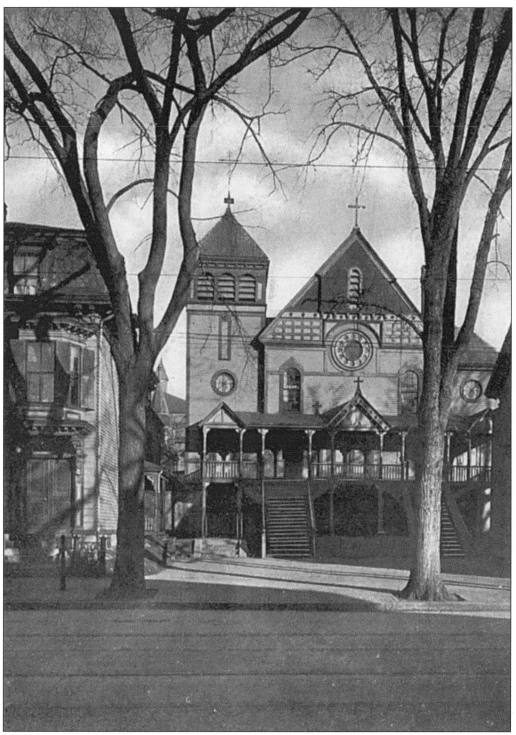

The second St. Joseph's Catholic Church, at 135 Lafayette Street, was a wooden structure dedicated on August 25, 1885. It was replaced by a Romanesque Revival, twin-towered building in 1913. The present structure replaced that building in 1949.

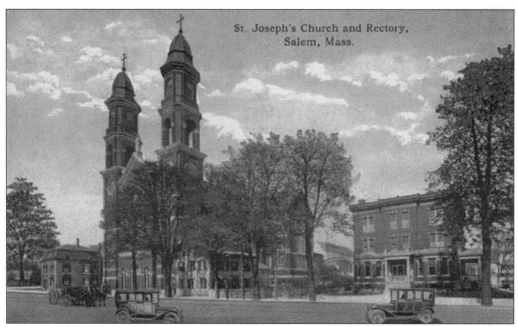

St. Joseph's Catholic Church and Rectory on Lafayette Street were substantial edifices built in 1913 to replace the wooden structures of 1885. Neither building could withstand the Fire of 1914, which destroyed both.

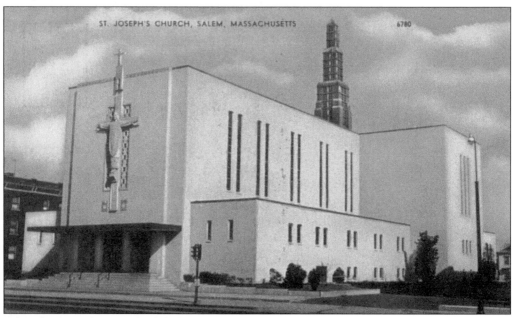

After the Fire of 1914, which left St. Joseph's Church a shell, parishioners used the renovated basement until 1949, when the present building was constructed. The architect, James J. O'Shaunessey, designed the building in a cruciform plan.

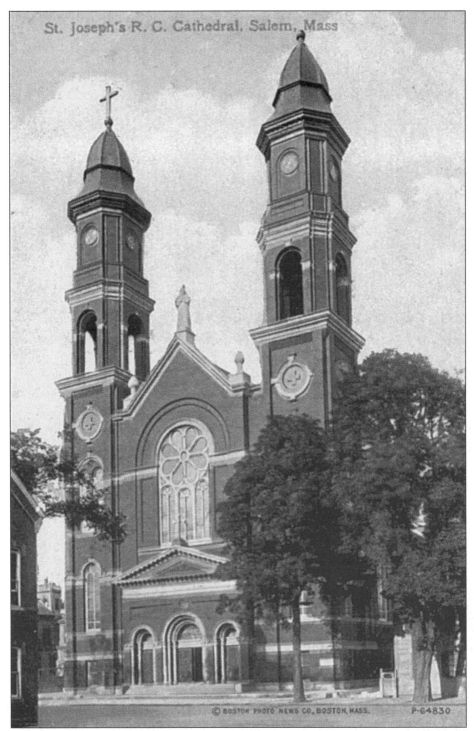

St. Joseph's R. C. Cathedral, Salem, Mass

© BOSTON PHOTO NEWS CO., BOSTON, MASS. P-64830

This postcard had been mislabeled, calling the impressive St. Joseph's a cathedral instead of a church. The immensity of the structure probably led to the confusion.

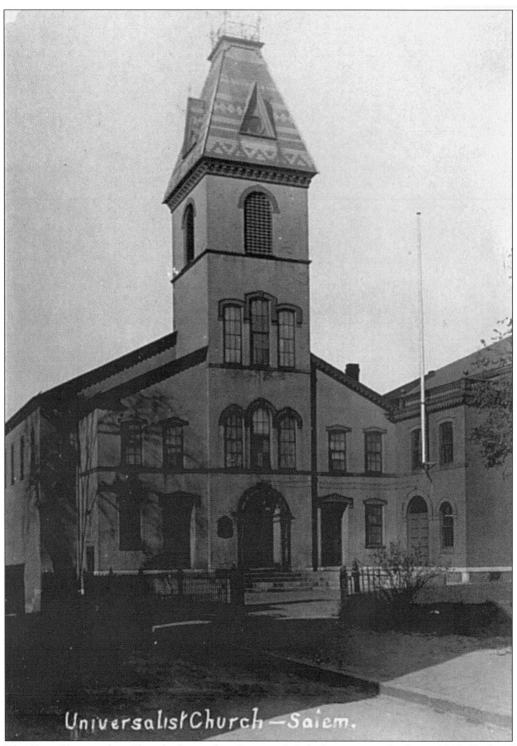

Universalist Church — Salem.

The First Universalist Church, located at Rust and Ash Streets, was built in 1808. Built of brick, it was completed in what was then the popular Federal style.

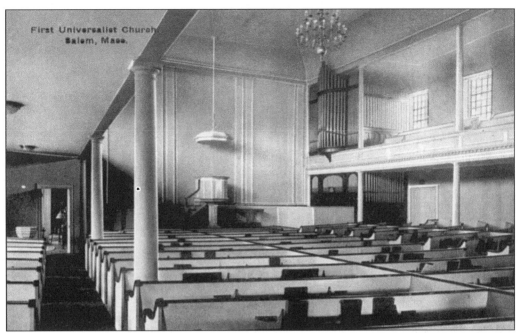

The top postcard shows the interior of the First Universalist Church. Looking through the doorway, on the left, is the Pastor's study (also seen below). Note the lamp, side chair, and rug, which appear in both pictures.

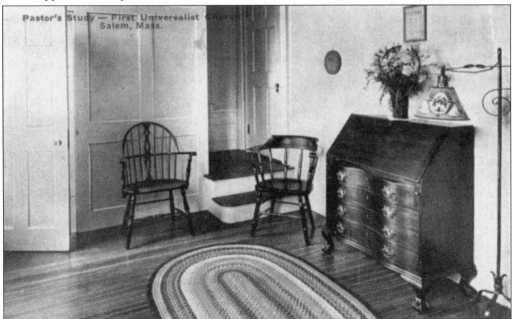

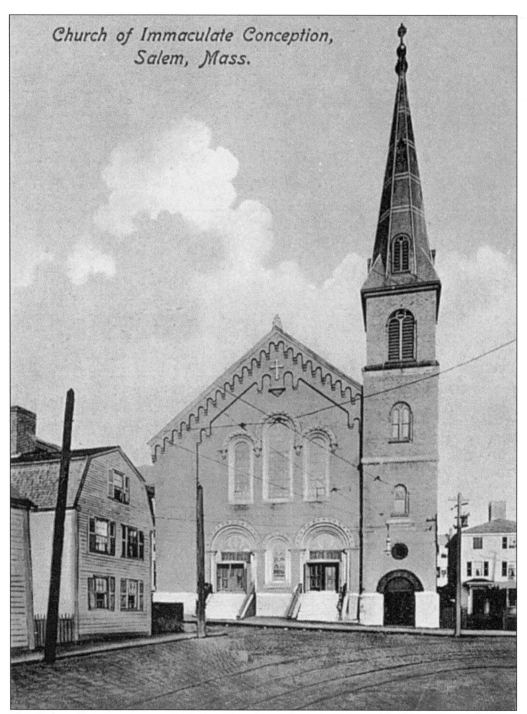

Church of Immaculate Conception,
Salem, Mass.

The Immaculate Conception Catholic Church was built in 1857, in the Romanesque Revival style. After a number of alterations, the bell tower was added in 1880. Built by architect Enoch Fuller (1828–1861) the church is the oldest Catholic ecclesiastical building in the city. This postcard shows the church on Walnut Street, before becoming Hawthorne Boulevard in 1917.

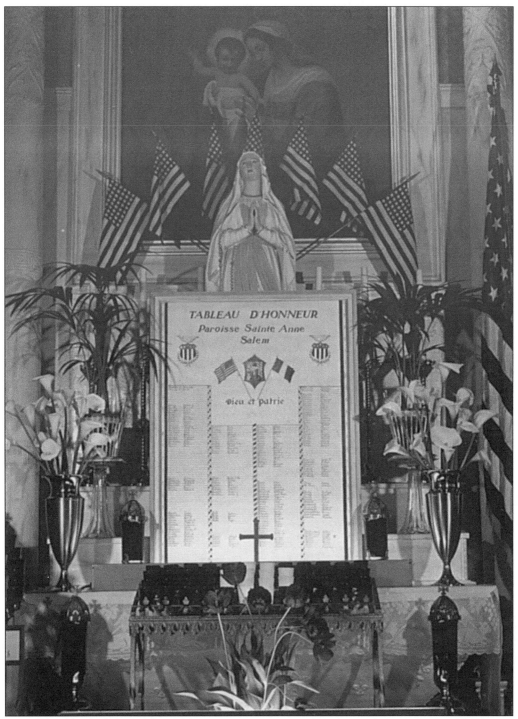

This photograph shows the side altar in St. Anne's Catholic Church on Jefferson Avenue. The Honor Roll, in French, stands out clearly. Dedicated in July 1943, it was inscribed with the names of 201 members of the parish. These parishioners were serving in various branches of the military, two of whom had died by that time in defense of the nation.

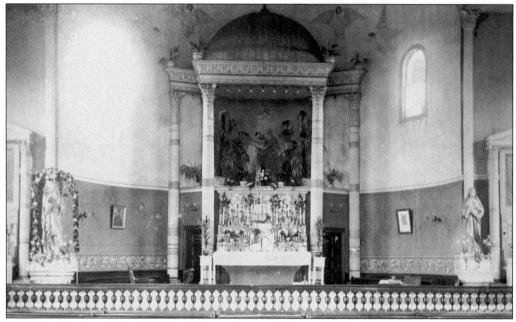

Ste. Anne's was built in 1901 by Salem architect William Devereux Dennis (1847–1913) and dedicated in 1902. The building was destroyed in a fire on February 3, 1982. The main altar is shown in this extremely rare postcard issued before the 1926 redecorations.

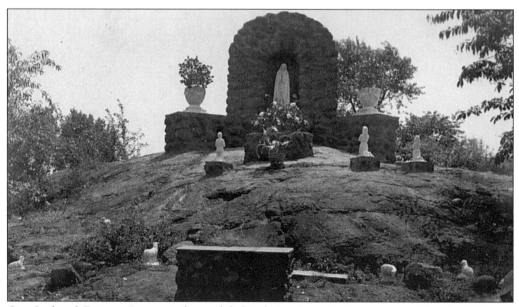

Our Lady of Fatima Grotto is located behind St. Anne's Convent on Cleveland Street. The grotto, dedicated in August 1951, was donated by builder Antonio Pelletier and the statues donated by Monsignor William Drapeau.

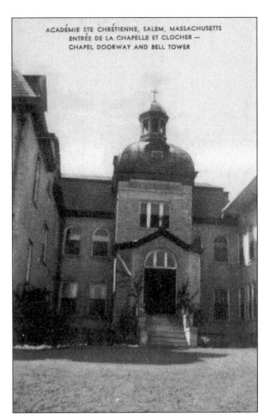

ACADÉMIE STE CHRÉTIENNE, SALEM, MASSACHUSETTS
ENTRÉE DE LA CHAPELLE ET CLOCHER —
CHAPEL DOORWAY AND BELL TOWER

The St. Chretienne Academy Complex contained a Chapel in which the nuns and students could worship. The upper photo displays the rather austere chapel doorway and heavy bell tower. The exterior, however, belied a delicate interior, shown below. The flower-bedecked altar was perfectly complemented by the backdrops for the statues and the painted stars on the ceiling.

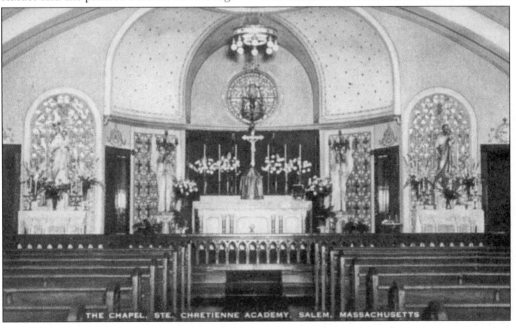

THE CHAPEL, STE. CHRETIENNE ACADEMY, SALEM, MASSACHUSETTS

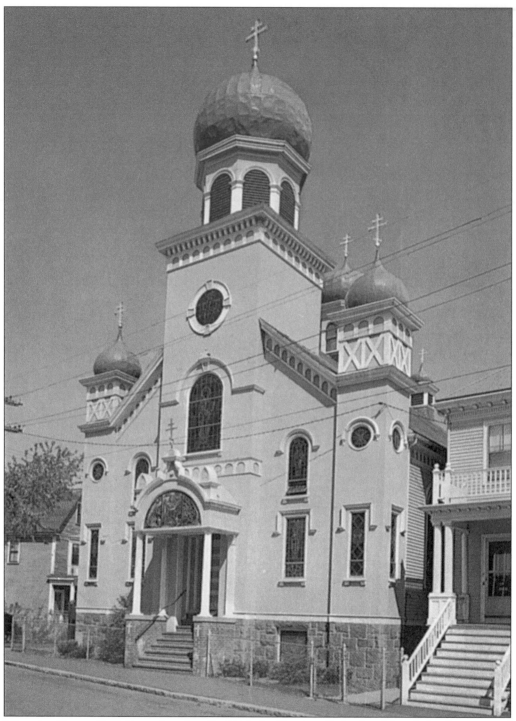

Historian Bryant F. Tolles writes that St. Nicholas Russian Orthodox Church "ranks as one of the finest Byzantine Revival ecclesiastical buildings surviving in New England." Built to serve immigrants from Poland and Russia who came to work in the leather and shoe factories of the area, the church was dedicated on November 8, 1908.

Four
PUBLIC SERVICE

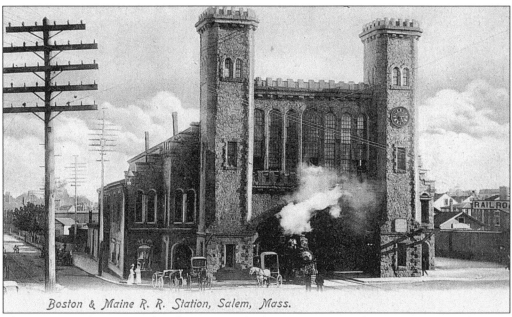

Boston & Maine R. R. Station, Salem, Mass.

The Boston and Maine Railroad Depot was built in 1846–47, at the junction of Washington and Norman Streets (Riley Plaza). The noted Boston architect Gridley J.F. Bryant designed this building in a style reminiscent of a castle that would stand forever. Unfortunately, it could not withstand the pressure of development and was razed in 1954.

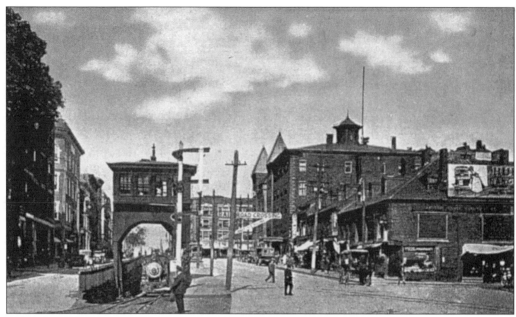

Salem was an important railroad center at the beginning of the 20th century. Together with Lynn, Salem had one of the few freight yards in the area. The switch tower, prominent in both of these postcards, was located in the center of Washington Street. The entrance to the Boston and Maine tunnel was under Town House Square. The top card shows four types of transportation used at this time: horse-drawn carriages, automobiles, trains, and electric trolleys. (Courtesy Nelson Dionne.)

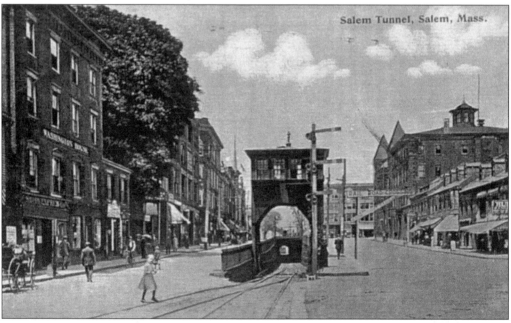

This 1905 view of Salem High School shows it to be a solid and stately building, but it was becoming inadequate and out of date. The Salem architect Enoch Fuller (1825–1861) built it in 1855–56 at 5 Broad Street. It later became the Salem Senior Citizens' Center.

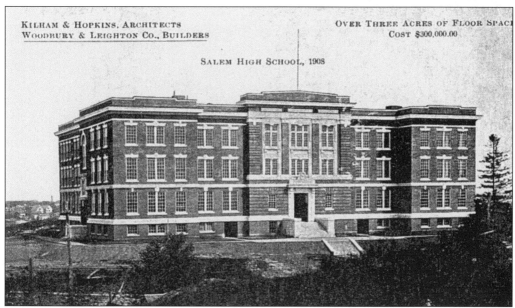

The new Salem High School opened in 1908 at 29 Highland Avenue. It was designed by Kilham and Hopkins and built by Woodbury and Leighton. It is now the Francis X. Collins Middle School. (Courtesy Nelson Dionne.)

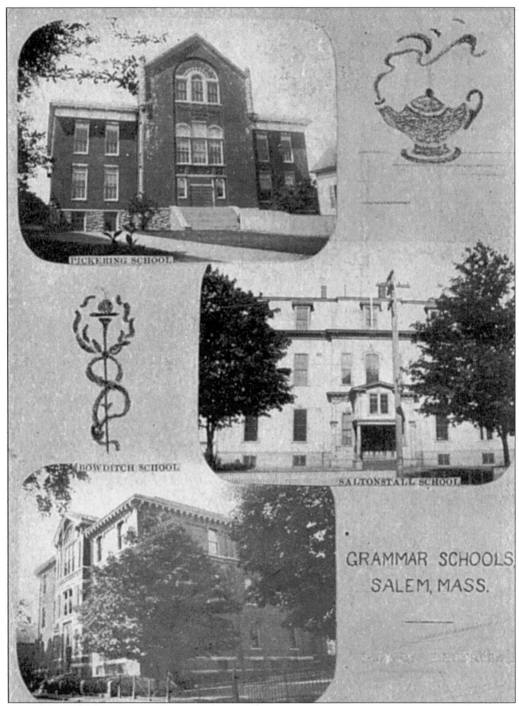

This privately printed card by E.F. Perley of Salem presents three grammar schools. At the top is the Pickering School, built in 1893 at 181 North Street. Next is the old Saltonstall School on Holly Street, constructed of wood in 1874. It was originally called the Browne School and later the Holly Street Grammar School. On the bottom is the Bowditch School, built in 1867 at 35 Flint Street.

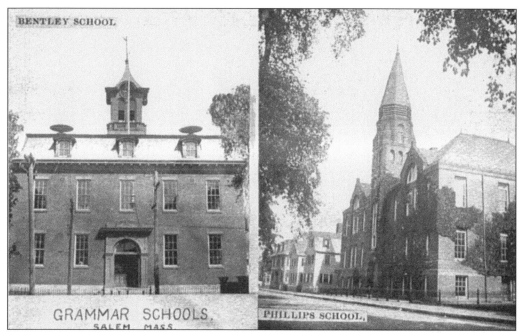

Another card by E.F. Perley shows two more grammar schools. On the left is the Bentley School built in 1861 at 50 1/2 Essex Street. This later became the East Branch of the Salem Public Library, unfortunately without the top two floors. Paired with this is the Phillips School at 50 Washington Square South.

This postcard captures St. Joseph's Convent on Harbor Street as it appeared prior to 1907. As this parish served a French community of Salem, it is appropriate that the nuns lived in a Second Empire-style house. Note the eclectic tower on this classic building.

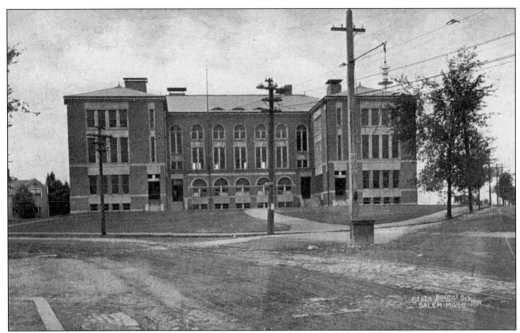

The State Normal School was built in 1893–96 by Boston architect J. Philip Rinn. On the left is Lafayette Street, and Loring Avenue leads off to the right. This building is now one of the main components of Salem State College.

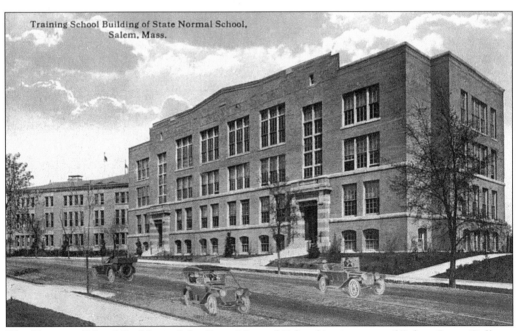

The Training School Building of the State Normal School is now part of Salem State College. Note the trolley tracks running down the middle of Loring Avenue.

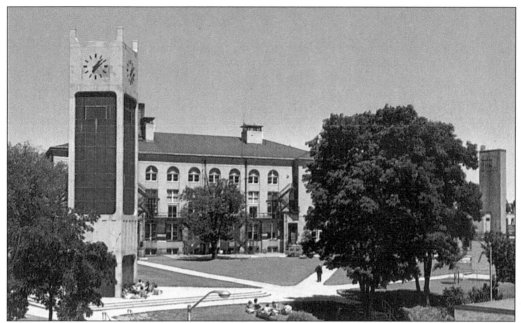

A short-lived structure at Salem State College was the Clock Tower, which was built in the mid-1960s and came down in June of 1990.

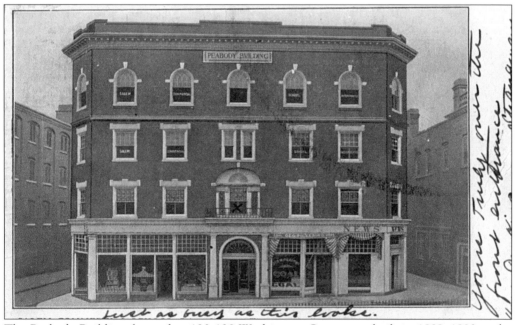

The Peabody Building, located at 120-128 Washington Street, was built in 1889–1890 as the headquarters for the *Salem Evening News*. By the time of this 1907 card, a fourth floor had been added. The Salem Commercial School leased the top two stories. An annual school bulletin of 1920 called it "one of the leading business colleges in the country." Notice the George Pickering Coal Company in the storefront on the right.

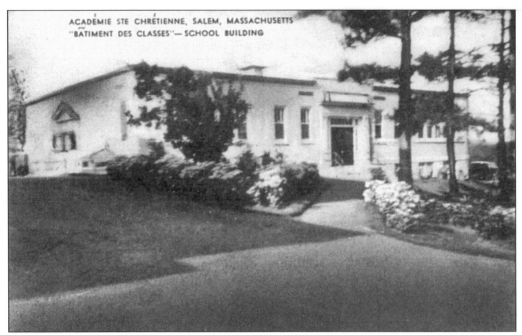

ACADÉMIE STE CHRÉTIENNE, SALEM, MASSACHUSETTS
"BATIMENT DES CLASSES"— SCHOOL BUILDING

The upper card shows St. Chretienne Academy as it was built in 1936 by contractor Charles F. Maurais. By 1948, the Henry Goudreau Company had added two more floors, as seen in the lower card. There was a tunnel connecting the school to the convent for the nuns' security and comfort. The entire complex was sold to Salem State College in 1972 and still serves as its south campus.

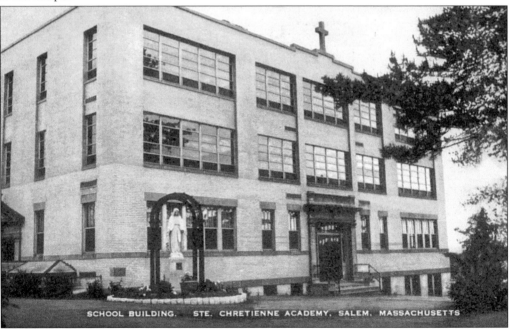

SCHOOL BUILDING. STE. CHRETIENNE ACADEMY, SALEM, MASSACHUSETTS

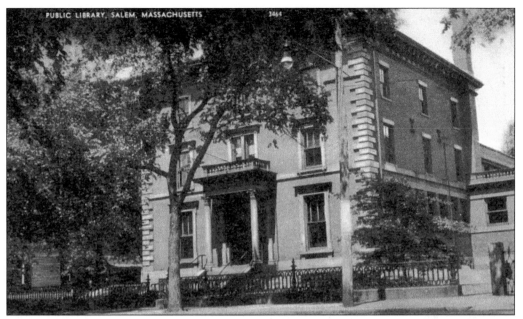

PUBLIC LIBRARY, SALEM, MASSACHUSETTS 3464

The Salem Public Library building at 370 Essex Street was built in 1855 as the residence of Captain John Bertram. His heirs gave it to the city and it was renovated for library use. This card shows it after the 1911–12 renewal and expansion. The one-story ell to the right was added as a reference room. At the same time, unseen here, a four-story book stack ell and office / cataloging wing were constructed.

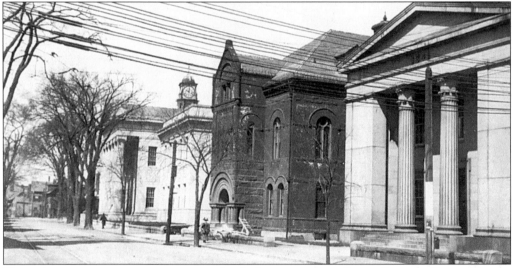

This glorious streetscape is composed of the successive Essex County Court Houses. Each building is a superb example for its time of public architecture that sought to ennoble and uplift all who entered or passed by. Located on Federal Street at the corner of Washington Street, the building on the right was built in 1839–41 in the Greek Revival style. The center edifice, built of brick and brownstone, was erected in 1861–62 in Italian Revival style but was altered in 1887 and 1889 and took on the look of a Richardsonian Romanesque style. The Neoclassical Revival building on the left was erected in 1908–09 to house the registry of deeds, probate department, and administrative offices.

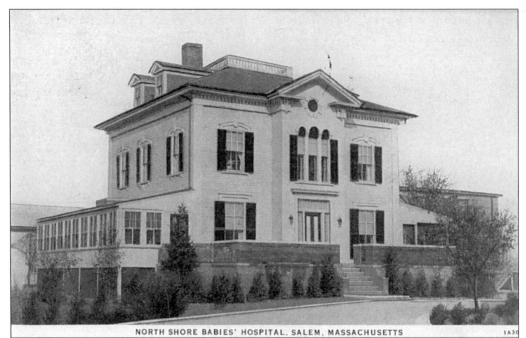

NORTH SHORE BABIES' HOSPITAL, SALEM, MASSACHUSETTS

The former North Shore Babies' Hospital, shown here as it appeared in 1932, was built c. 1856 as a residence for Charles A. Ropes at 75 Dearborn Street. It was destroyed by fire in 1972. Established for reducing infant mortality, it could accommodate 50 infants. Miss Dorothy Smith was superintendent during the 1930s.

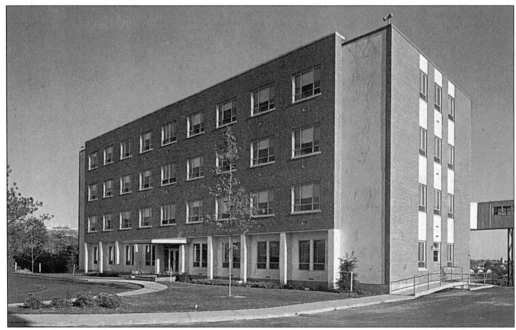

The new building for the North Shore Babies' and Children's Hospital opened in 1961 on Highland Avenue. It could serve many more patients in a more efficient manner but lacked any significant architectural style.

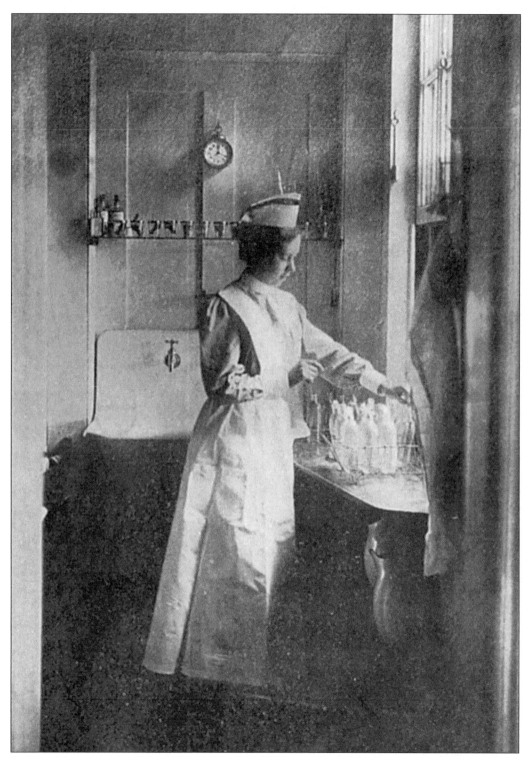

A "Diet Nurse" in the Salem Hospital before 1907 attends to her duties, attired in her proper starched uniform.

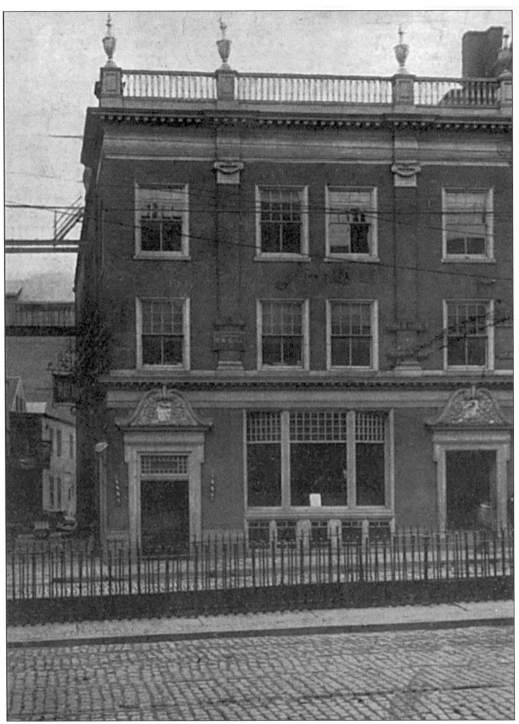

In 1909, this U.S. Post Office building at 118 Washington Street was still in good condition and retained its original detailing. Constructed in 1882–83 by Boston architects Peabody and Sterns, it served Salem residents for many years in refined understatement. The building remains but lacks its ornamentation.

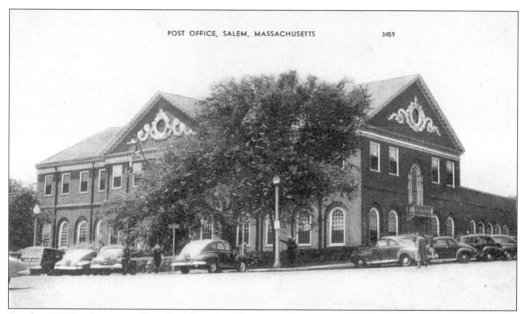

By the 1930s, the post office building had become inadequate. This new building at 2 Margin Street was finished to the design of Wenham architect Philip Horton Smith. His firm of Smith and Walker gave it a Colonial Revival style and it opened on July 13, 1933.

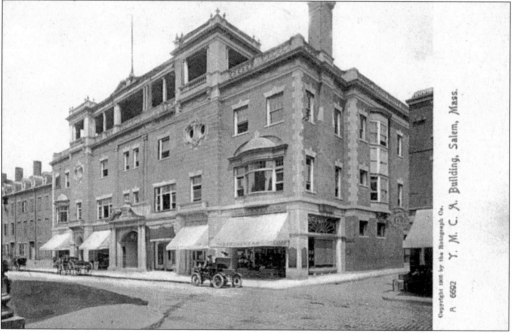

The YMCA building at 284-296 Essex Street, corner of Sewall, was built in 1897–1898 in an eclectic style by the Beverly architect Walter J. Paine. The mixture of elements from many different design traditions made this a very rich façade. The fourth floor loggia, now lacking, was for viewing parades on Essex Street. On this site, in the Sanders homestead, between 1873 and 1876, Alexander Graham Bell conducted experiments leading to the invention of the telephone.

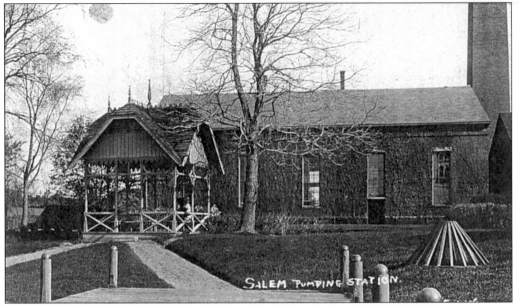

Salem's major water supply is Wenham Lake. The Salem pumping station pictured here "opened on January 23, 1895, at 3:00 p.m. in the presence of about a thousand people who had arrived by special train." Note the stick-style gazebo and the dock on Wenham Lake in the foreground.

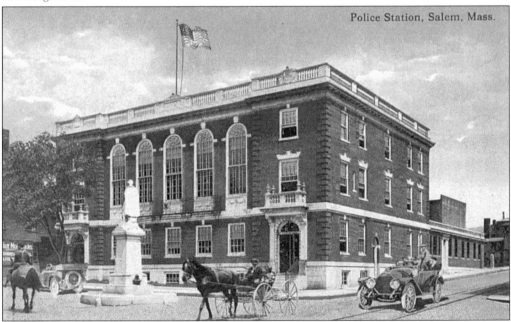

Built in 1913 by local architect John M. Gray, the Salem Police Station at 17 Central Street also housed the Essex County District Court until 1977. This postcard was probably produced to commemorate the opening of the Colonial Revival building. The police station relocated to a new building on Jefferson Avenue, at Margin Street, after its dedication on December 17, 1992. Note the monument to Father Matthew in the foreground, now located on Hawthorne Boulevard.

Five

BUSINESSES

Produce dealers are seen selling their wares on a Saturday morning in this view of the Market House and Derby Square. The Market House was built in 1816 in the Federal style. The market was located on the first floor, and the town meetings were held on the second floor until 1836, when the new City Hall was built.

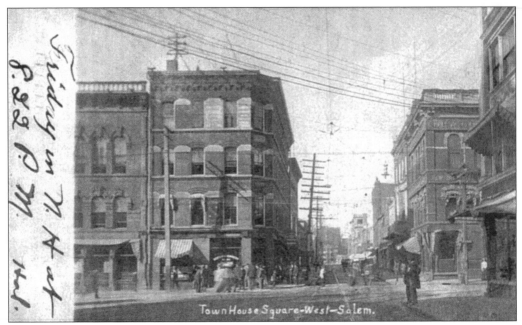

Town House Square—West—Salem.

The intersection of Essex and Washington Streets, known as Town House Square, has served shoppers as a busy mercantile district for years. Two views show the area at different periods. The top card is looking west prior to 1907. It was at that date that cards were divided on the back so that a message could be written; before this date, the message appeared on the front as in this example. The bottom card shows Essex looking east, c. 1930.

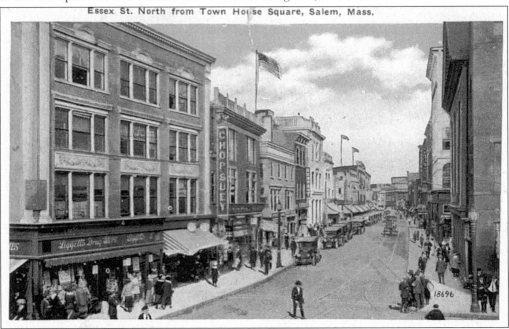

Essex St. North from Town House Square, Salem, Mass.

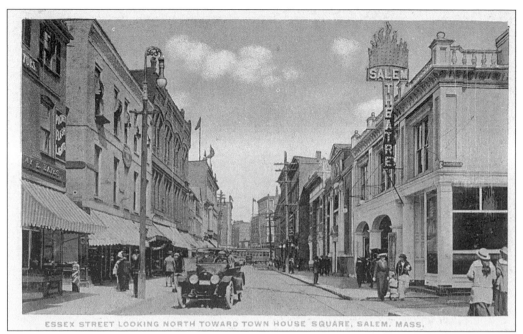

ESSEX STREET LOOKING NORTH TOWARD TOWN HOUSE SQUARE, SALEM, MASS.

Shoppers stroll down Essex Street in this *c.* 1910 card. Notice the Salem Theatre, which opened on April 25, 1901, with *Way Down East* and remained in operation until the mid-1930s.

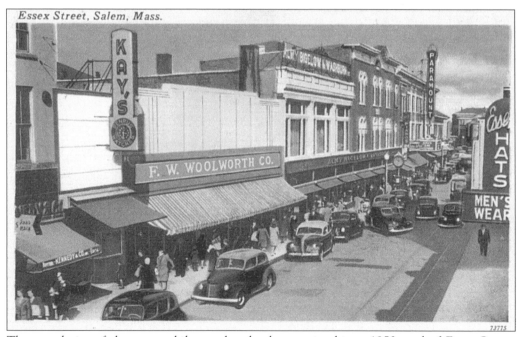

The popularity of the automobile can be clearly seen in this *c.* 1950 card of Essex Street. Several popular businesses can be seen, including Kennedy's Butter and Eggs, Kay's Jewelers, Almy's Department Store, and the Paramount Theatre.

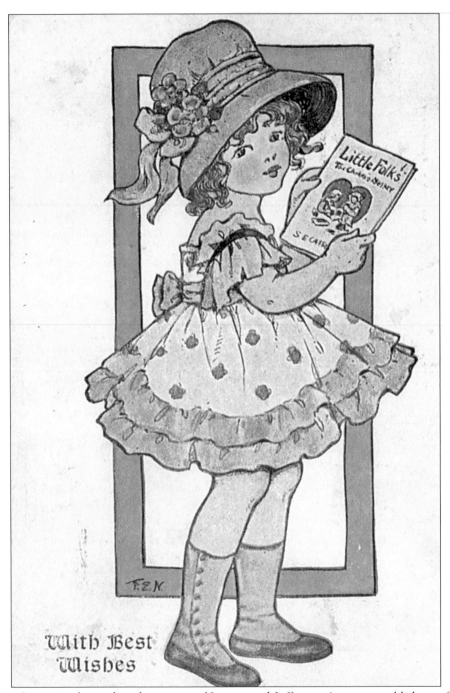

Cassino Company, located at the corner of Loring and Jefferson Avenues, publishers of *Little Folks Magazine*, mailed this Christmas postcard to recipients of gift subscriptions during the holiday season of 1918.

SALEM, MASS., 12/18, 1913

Dear Friend:

Your Favor of *Dec. 13th*

With Enclosure of $ *5.20* is Received

and will be attended to according to instructions.

In Writing About
This Order Always
Refer to No.

Very Truly,
S. E. CASSINO CO.,
By *S. S.*

These two cards attest to the popularity of the postcard as an advertising medium. The top card was for *Little Folks Magazine*, which was distributed nationally. The bottom card hawked the wares of A.C. Titus and Company, a furniture store on Jefferson Avenue, as the perfect Christmas gifts in 1911.

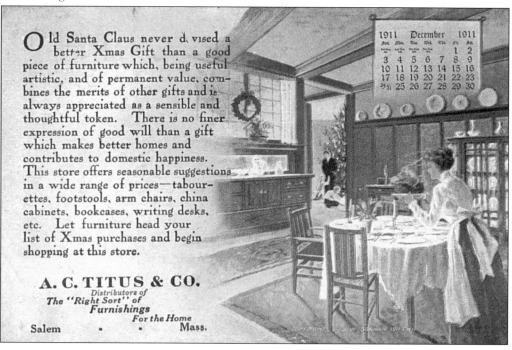

Old Santa Claus never devised a better Xmas Gift than a good piece of furniture which, being useful artistic, and of permanent value, combines the merits of other gifts and is always appreciated as a sensible and thoughtful token. There is no finer expression of good will than a gift which makes better homes and contributes to domestic happiness. This store offers seasonable suggestions in a wide range of prices—tabourettes, footstools, arm chairs, china cabinets, bookcases, writing desks, etc. Let furniture head your list of Xmas purchases and begin shopping at this store.

A. C. TITUS & CO.
Distributors of
The "Right Sort" of
Furnishings
For the Home
Salem • • Mass.

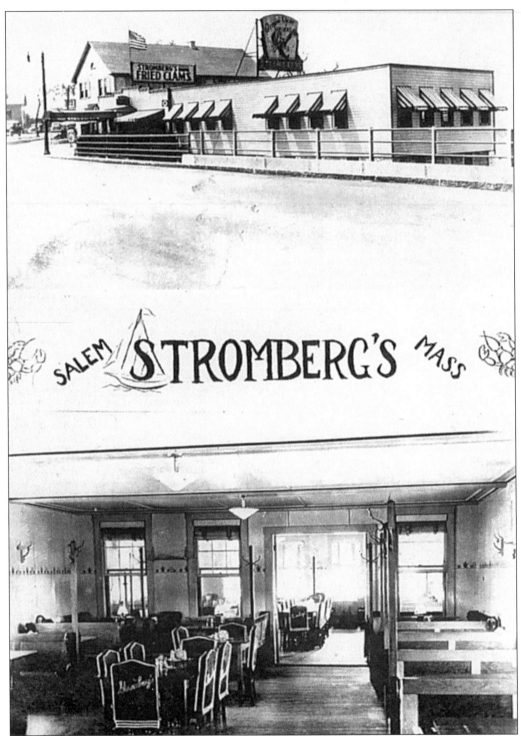

Stromberg's, a Salem fixture famous for its fried clams and seafood since 1931, is located on Route 1A, at 2 Bridge Street. Pictured here is the building as it appeared after its 1938 addition. (Courtesy Nelson Dionne.)

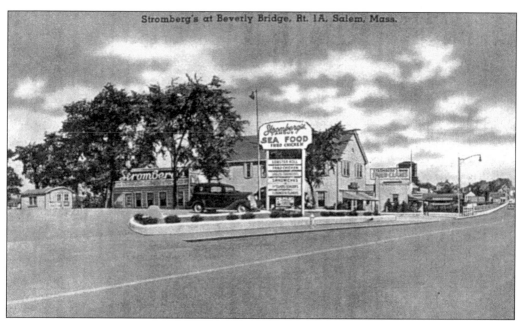

Stromberg's at Beverly Bridge, Rt. 1A, Salem, Mass.

Two advertising cards show an expanded Stromberg's, *c.* 1950. Both cards stressed the restaurant as "A Fine Place to Eat." The top card shows the Beverly Bridge as a drawbridge. The building on the left in the bottom card (since razed) was later a candy store. It was called Rice's Candy Anchorage and was located at 4 Bridge Street in the 1950s and 60s.

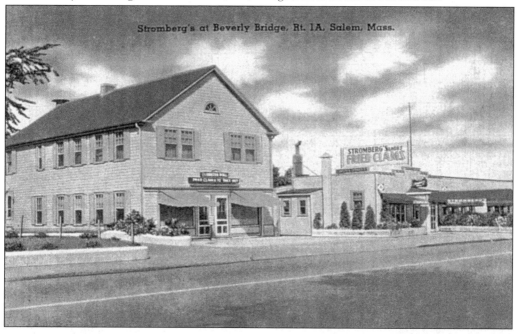

Stromberg's at Beverly Bridge, Rt. 1A, Salem, Mass.

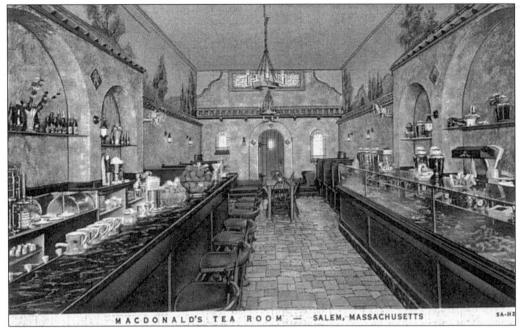

MACDONALD'S TEA ROOM — SALEM, MASSACHUSETTS SA-H2

Macdonald's Tea Room, which opened in the early 1930s at 249 Essex Street, attempted to recreate a "Spanish Courtyard." The card states this is "a unique setting in which to enjoy the delicious food, ice cream, soda, and candy served by this unusual shop." (Courtesy Nelson Dionne.)

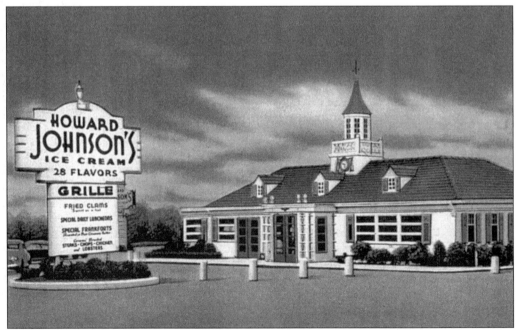

Howard Johnson's evokes strong memories of a time gone by. This generic card depicts a restaurant similar to the one on Bridge Street. On the back of the card is a section for customers to rate the food. (Courtesy Nelson Dionne.)

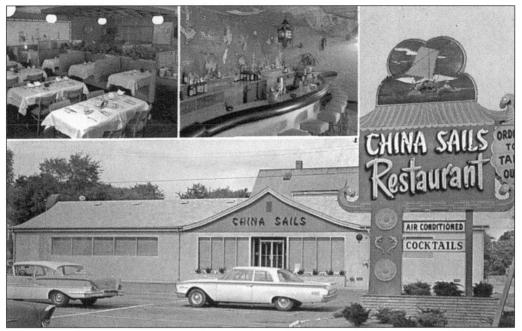

Opened in September of 1959, China Sails at 516 Loring Avenue on the Swampscott-Marblehead line was a popular destination for many years. The restaurant changed ownership and became Fantasy Island, c. 1981.

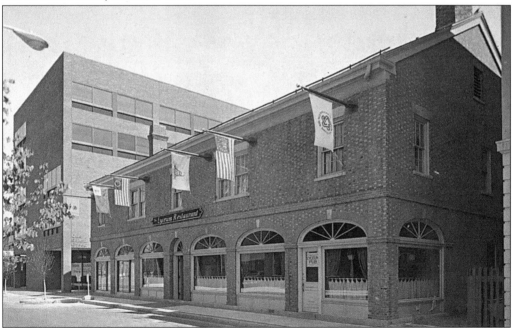

The Lyceum Restaurant and Pub at 35-43 Church Street is located on the site of the home of accused witch Bridget Bishop. Established as a forum for learning in 1830, the building opened in 1831. It was here, on February 12, 1877, that Alexander Graham Bell gave the first public demonstration of the telephone. The building has undergone much reconstruction and has housed numerous businesses. It has been home to this popular restaurant since 1972.

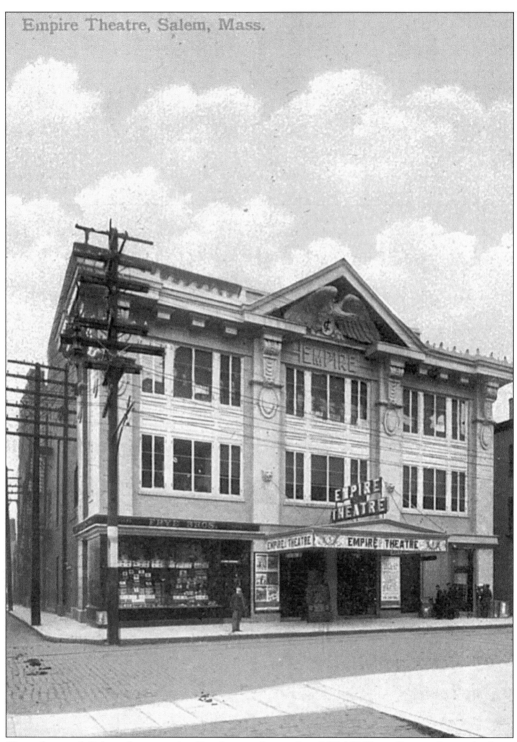

Empire Theatre, Salem, Mass.

One of several Salem theatres, the Empire was located at 285 1/2 Essex Street. It was built in 1906 with two balconies, on the site of Mechanic's Hall, and opened on August 29, 1907. For over 50 years, the theatre offered entertainment to patrons. It closed in 1958.

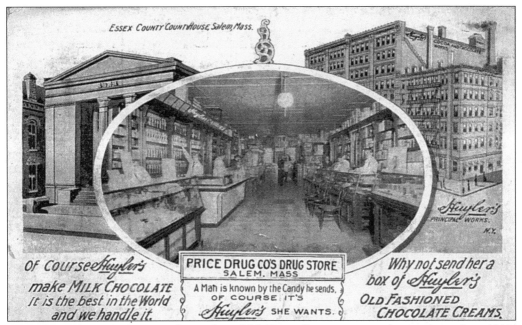

Price Drug Company's store, located at 226 Essex Street, was in business until *c.* 1910. This advertising card shows the interior of the store. (Courtesy Nelson Dionne.)

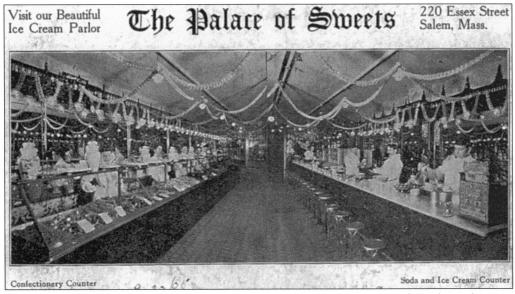

Located in the Jacob Rust brick store, built *c.* 1801 at 220 Essex Street, The Palace of Sweets surely would appeal to the sweet tooth in all of us. Opened on April 9, 1904, it featured an onyx soda fountain, mahogany fixtures, mirrored walls, and over 200 lights. The establishment became Moustakis' Ice Cream Parlor, *c.* 1914. (Courtesy Nelson Dionne.)

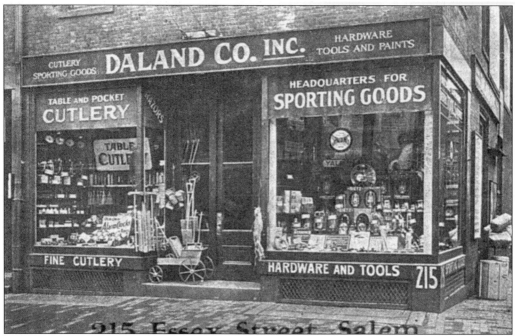

"The Hardware Men," Daland and Company, Inc. at 215 Essex Street, was located in the Pickman-Derby Building, built in 1817. A hardware and sporting goods store established c. 1905 and in operation until 1930, the company advertised "the best line of cutlery outside of Boston." This building is now the site of the Derby Square Bookstore. (Courtesy Nelson Dionne.)

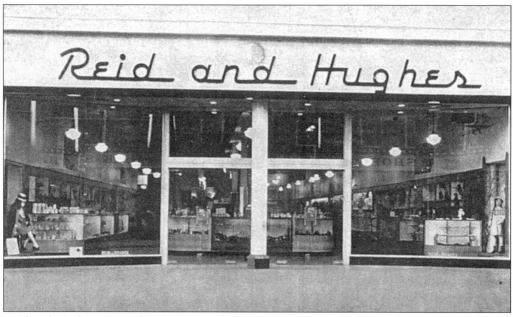

Reid and Hughes, a popular clothing and department store at 182 Essex Street, operated for a quarter century beginning in 1939. (Courtesy Nelson Dionne.)

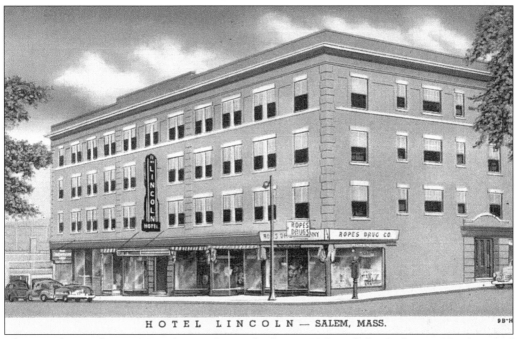

HOTEL LINCOLN — SALEM, MASS.

The Hotel Lincoln at 117 Lafayette Street, built in 1926, and the Lafayette Hotel at 116 Lafayette Street, built in 1915, catered to tourists visiting the city. Both cards show a variety of businesses from the 1950s and 60s that were located on the ground levels.

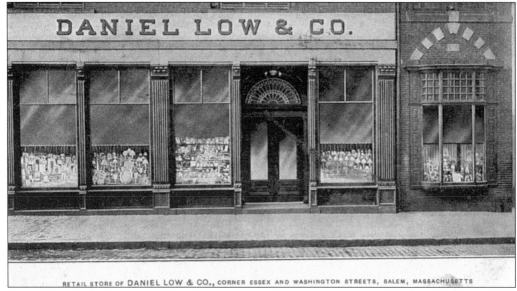

RETAIL STORE OF DANIEL LOW & CO., CORNER ESSEX AND WASHINGTON STREETS, SALEM, MASSACHUSETTS

Daniel Low and Company, Salem's premier retail store, was in business from 1867 to 1995. The building, located at 231 Essex Street at Washington Street, was built in 1826 as the First Church. It was remodeled in 1874 in the High Victorian Gothic style, and Daniel Low and Company leased the first floor at that time. The company acquired the building in 1923 when the First Church and the North Church merged.

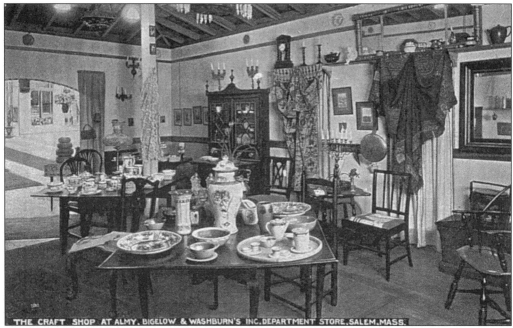

THE CRAFT SHOP AT ALMY, BIGELOW & WASHBURN'S INC. DEPARTMENT STORE, SALEM, MASS.

Almy, Bigelow, and Washburn's at 184-196 Essex Street was Salem's largest department store. Established in 1858, the store closed its doors in February of 1985. The Craft Shop pictured here was probably created in response to the great interest in both the Arts and Crafts and Colonial Revival movements popular early in this century. Here, period furniture intermingles with imported china and craft items. (Courtesy Nelson Dionne.)

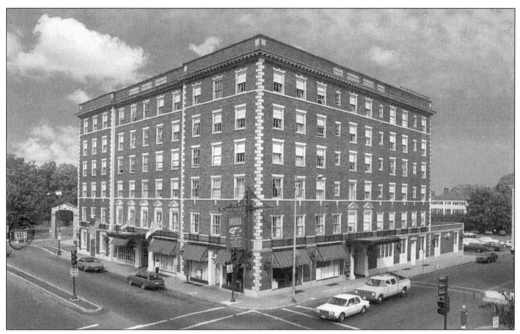

Salem's grandest hostelry, the Hawthorne Hotel at 18 Washington Square West, has served visitors since its opening on July 23, 1925.

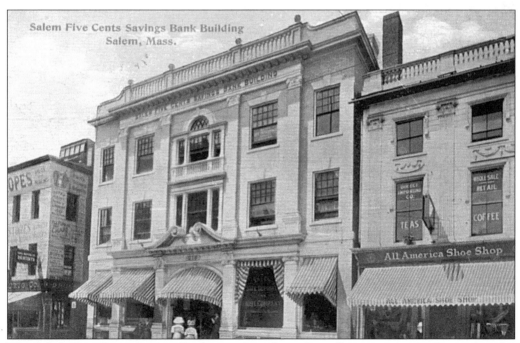

The Salem Five Cents Savings Bank served residents for well over a century. Located in the Gardener Building at 210 Essex Street since 1893, the bank first opened its doors in May 1855 on Pickman Place. On its first day, 84 depositors opened accounts and the bank grew and prospered. In 1914, the building shown on this card was remodeled.

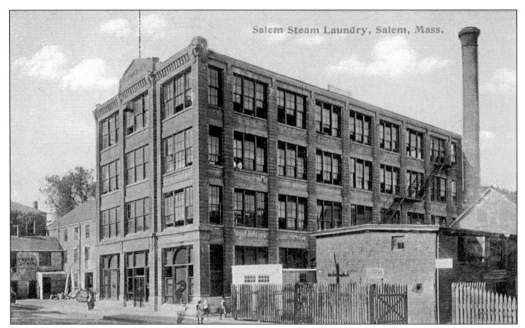

The Salem Steam Laundry was located at 47 Lafayette Street. The building, opened in August 1907, is constructed of poured concrete block. The printer tinted the image red to give the impression that it was constructed of brick. This building exists today, much altered and sandwiched between two other structures, without the cornice at the roof line and with replaced windows.

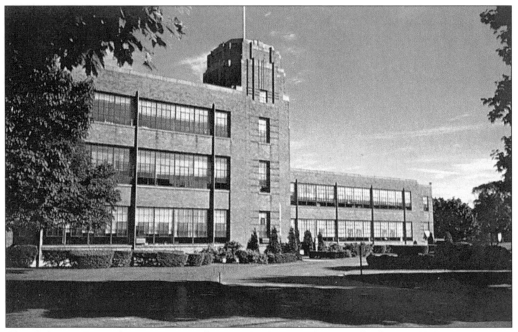

The Sylvania Incandescent Lamp plant at 71 Loring Avenue, built in 1936, at one time produced more than 5,000 different lamp types, "each one quality engineered." The plant was taken over by Salem State College, renovated, and opened in 1998 as the Academic Center.

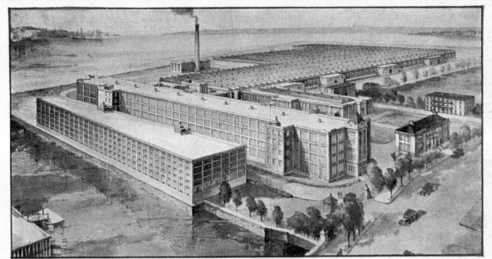

PEQUOT MILLS — SALEM, MASSACHUSETTS, — home of the famous PEQUOT SHEETS and PILLOW CASES. — Adjoining the Mills is the PEQUOT HOUSE, a most interesting reproduction of the homes of the early settlers in Salem, and furnished in the 17th Century style.

The Pequot Mills, or Naumkeag Steam Cotton Company, at 20 Congress Street at Stage Point, Salem Harbor, replaced a brick factory complex destroyed in the Salem Fire of 1914. A fireproof construction, the complex covered ten acres. The most prominent feature is the tall tower containing four clocks at the main building. The Pequot House, at the front of the complex beside the South River, is a reproduction of a 17th-century home that was built for the Massachusetts Tercentenary celebration in 1930.

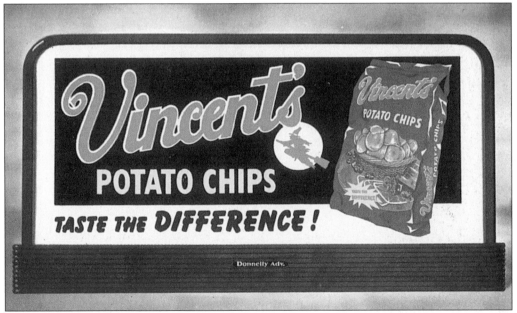

On June 18, 1999, an ad in *The Salem Evening News* read, "The only potato chip bag with a witch on the package has flown from Salem." Vincent's Potato Chips, a family-owned business, opened in Salem in 1953 after operating in Danvers since 1947. The potato chips are now being produced in the Boyd's plant in Lynn.

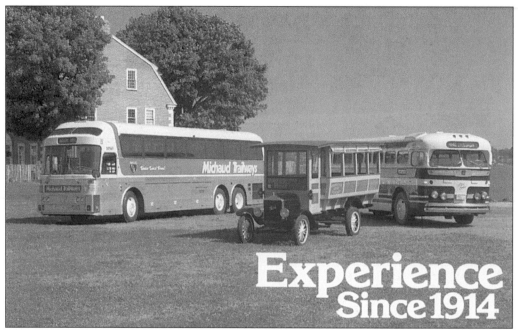

Experience
Since 1914

Since 1914, Michaud Trailways and Michaud Tours have offered the "finest in motorcoach travel." These two postcards show the type of equipment used by the company over the years.

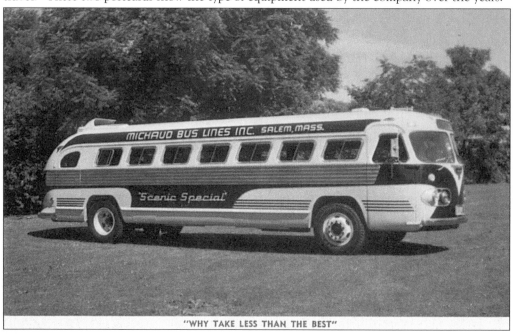

"WHY TAKE LESS THAN THE BEST"

78

Six
MUSEUMS AND PUBLIC BUILDINGS

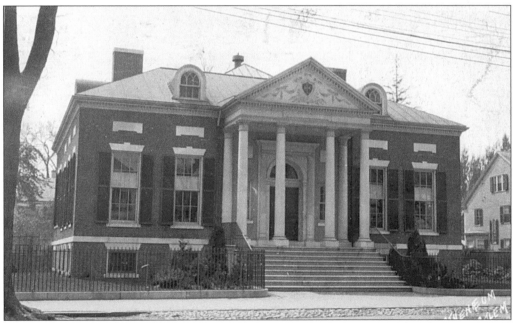

Since 1810, the Salem Athenaeum has been a private library. Its present headquarters at 337 Essex Street was built in 1906–07 by local architect William G. Rantoul in the Colonial Revival style. The building is modeled after "Homewood" on the campus of Baltimore's Johns Hopkins University.

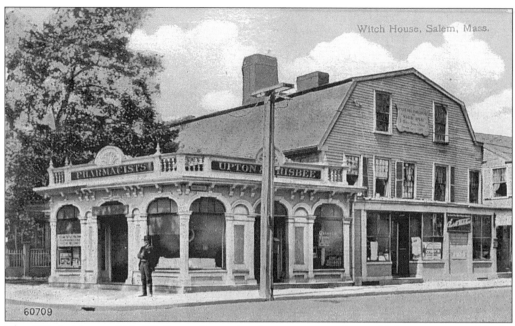

60709

The Witch House, 310 1/2 Essex Street in the top postcard, would be unrecognizable by today's residents and visitors. It is now believed that the original Jonathan Corwin House was built c. 1675. Since then the house has undergone numerous changes, including the addition of Upton and Frisbee's Pharmacy, as shown in this card. Saved from demolition and restored by Historic Salem (bottom card,) the City of Salem has operated the building as a museum since 1948.

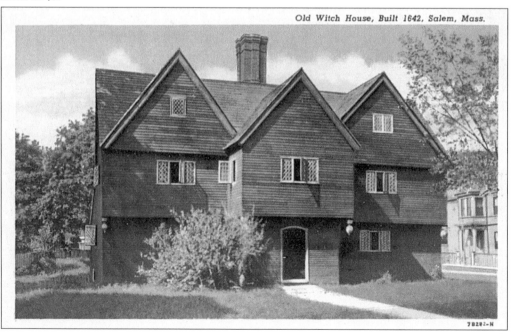

Old Witch House, Built 1642, Salem, Mass.

7B282-N

80

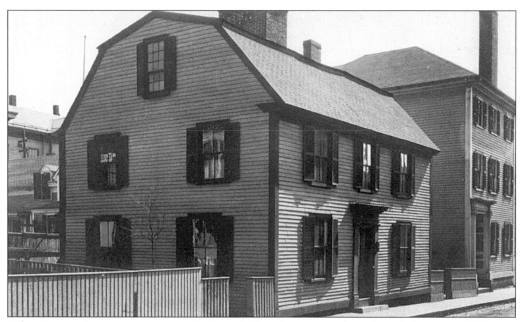

Salem's most famous native son, Nathaniel Hawthorne, was born in this house at 27 Union Street on July 4, 1804. Originally built between 1730 and 1745 for Joshua Pickman, the house was moved in 1954 to a site on the grounds of the House of the Seven Gables.

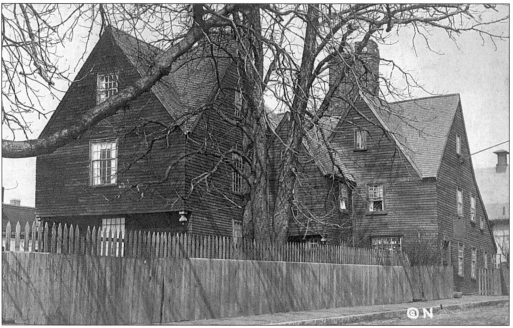

Salem's most famous building, the House of the Seven Gables, needs little introduction. Built in 1668 for Captain John Turner, the house has seen many remodelings. The House of the Seven Gables Settlement Association purchased and restored the house in 1908 and opened it to the public. The building is so called because of its association with the novel of the same name by Nathaniel Hawthorne. It is one of the city's most popular tourist attractions.

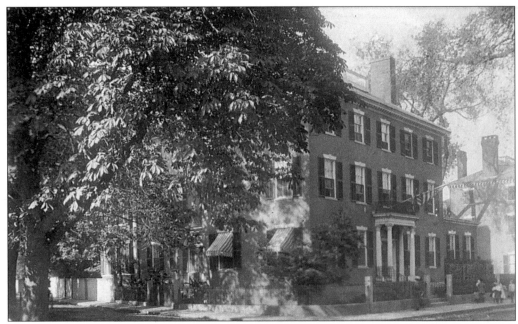

The Forrester-Peabody House at 29 Washington Square North was built in 1818–19 for John Forrester. The family lived here until 1834, when Colonel George Peabody purchased it. After 1892, it was occupied by the now defunct Salem Club, and then by the Bertram Home for Aged Men. Today it is known as the Bertram House, a residence for senior citizens.

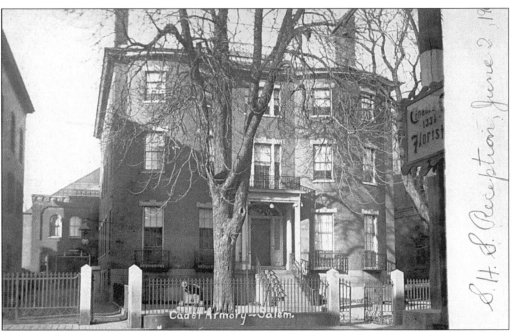

The Joseph Peabody House at 136 Essex Street was built in 1820. It served as the Salem Cadet Armory from 1890 until October 1907, when it was razed for the "new" armory. The photo dates to 1906.

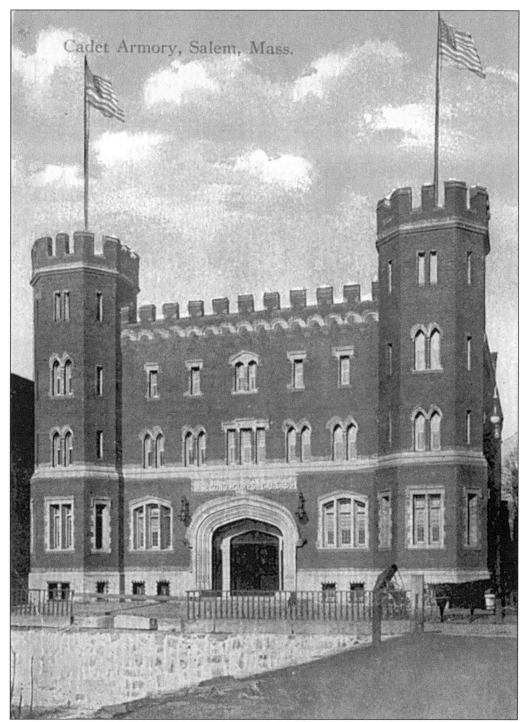

Cadet Armory, Salem, Mass.

The 1908 Cadet Armory was occupied by the 2nd Corps of Independent Cadets and Company H, 8th Regiment, Massachusetts Volunteer Militia. In February 1982, a fire ravaged the building with only the imposing façade surviving. The expansion of the Peabody Essex Museum threatens to destroy all that remains of this historic building.

Today all that remains of the Elks' Home at 17 North Essex Street bears little resemblance to this photograph. Only the bottom two floors now exist, covered by a flat roof. (Courtesy Nelson Dionne.)

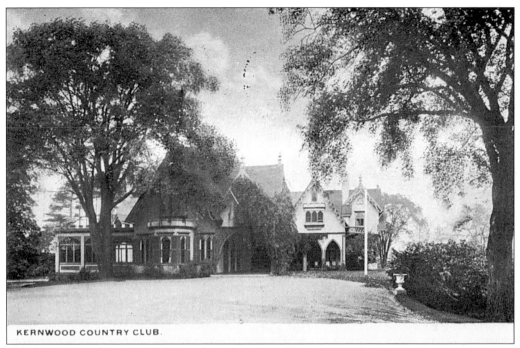

KERNWOOD COUNTRY CLUB.

The Kernwood Country Club (top,) organized in 1914, was built as a residence in 1840 by Francis Peabody. The bottom card shows an interior of the club. The sender of this card wrote, "Isn't this a lovely room. They call it the chapel."

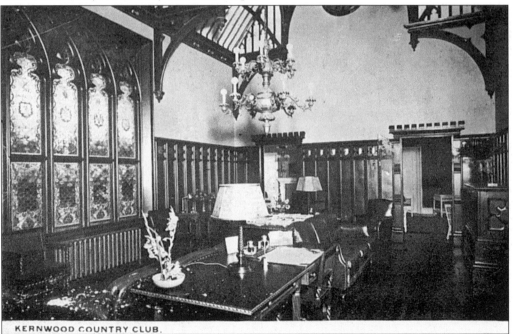

KERNWOOD COUNTRY CLUB.

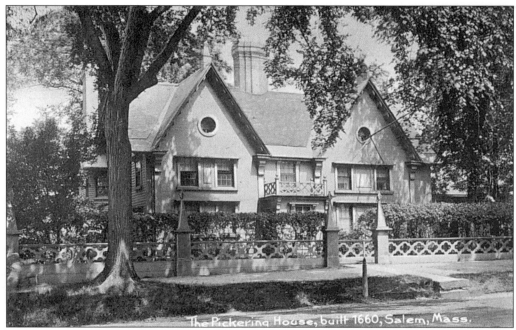

Located at 18 Broad Street, the Pickering House was built in 1651 and remodeled in 1841 in the then-popular Gothic Revival style. The house, open to the public as a museum, is the oldest residence in the United States continually occupied by the same family.

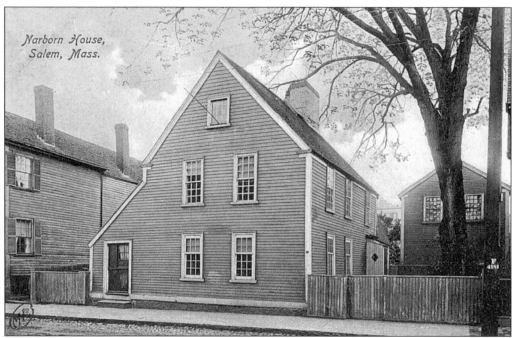

The National Park Service maintains the Narbonne House at 71 Essex Street, built in 1672, as a museum. The interior has not been restored and shows how the house has evolved since the 17th century.

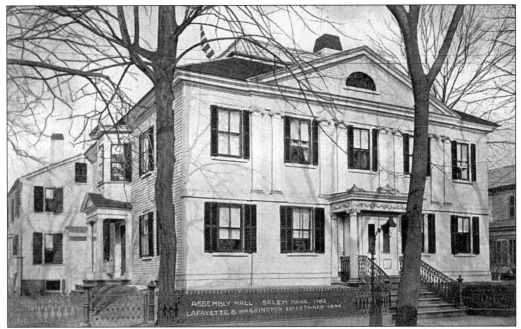

The 1782 Assembly House at 138 Federal Street was originally used for a variety of cultural and social programs. The Marquis de LaFayette and, later, Pres. George Washington visited here. Later the building was remodeled by Samuel McIntire (1757–1811) in the Federal style. The house is owned by the Peabody Essex Museum and is used for many of the same types of functions as it was originally intended.

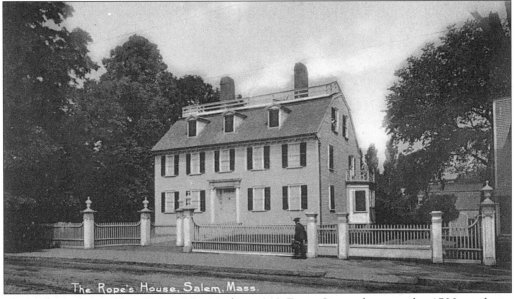

The Ropes Mansion or "Ropes Memorial" at 318 Essex Street dates to the 1720s and was originally built as a merchant's home. In 1768, the Ropes family purchased the property and continued to live there until 1907. The building has been extensively renovated but still possesses great charm and elegance. The building, open to the public since 1907, is operated as a house museum by the Peabody Essex Museum.

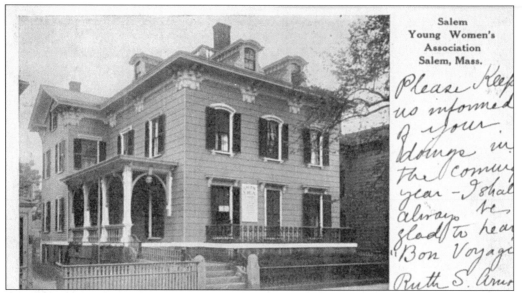

Salem Young Women's Association Salem, Mass.

Please keep us informed of your doings in the coming year — I shall always be glad to hear "Bon Voyage" Ruth S. Arm

This postcard shows the YWCA at 18 Brown Street. Called the Ives-Webb House, it was built in 1855–56 in the Italianate style. The YWCA, organized on October 19, 1857, used this building as its headquarters for many years until it disbanded in 1980. This card dates to *c.* 1907.

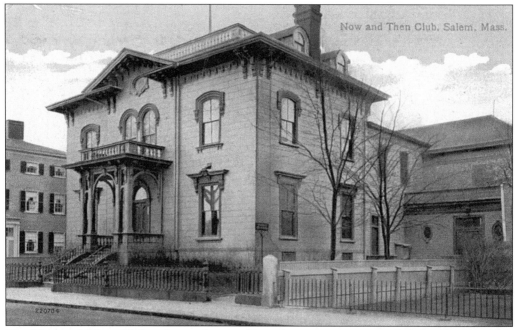

Now and Then Club, Salem, Mass.

The Now and Then Club, a benevolent and social organization, occupied the West-Benson House at 36 Washington Square beginning in 1905. According to the postcard's caption, this house was built in the 1860s by "Mrs. Benjamin West who was a great believer in spiritualism, and claimed the house was built from plans given to her by departed spirits who visited her in her sleep."

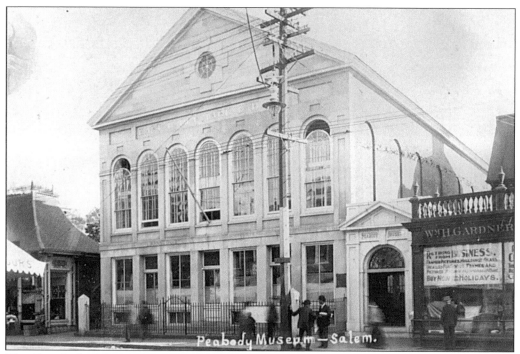

The East India Marine Society, established in 1799, built the East India Marine Hall in 1824–25 at 161 Essex Street. The Society was the forerunner of the Peabody Museum.

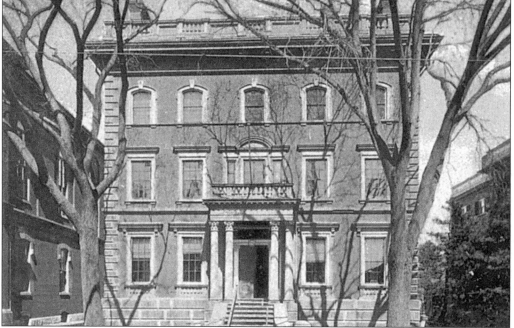

The John Tucker Daland House, 132 Essex Street, of 1851–52, was built in the Italianate style by Boston architect J.F. Gridley Bryant (1816–1899.) In 1885, the Essex Institute acquired the building from the Daland family and used it as its headquarters. Remodeled numerous times, it houses the library and offices of the Peabody Essex Museum.

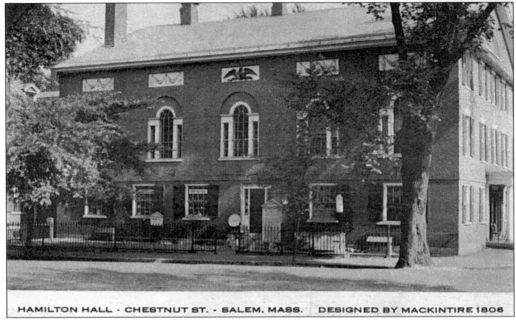

HAMILTON HALL · CHESTNUT ST. · SALEM, MASS. DESIGNED BY MACKINTIRE 1806

At the height of Salem's China Trade, merchant families could well afford an impressive social gathering place in the form of Hamilton Hall at the corner of Chestnut and Cambridge Streets. Built between 1805 and 1807 in the Federal style so popular in Salem, the building was designed by Samuel McIntire (1757–1811) and is named in honor of Alexander Hamilton.

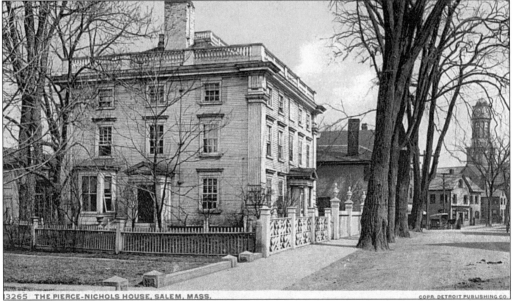

3265 THE PIERCE-NICHOLS HOUSE, SALEM, MASS. COPR. DETROIT PUBLISHING CO.

The Peirce-Nichols House at 80 Federal Street is another Federal-style building designed by McIntire in 1782 and remodeled by the architect in 1801 for the marriage of George Nichols and Sally Peirce. The first owner was Jerathmiel Peirce, one of Salem's most successful merchants who sought to build in the latest style. The house remained in the family until the Essex Institute purchased it in 1917. It was opened to the public in the late 1930s and is now part of the Peabody Essex Museum.

Seven

FIREFIGHTING AND FIRES

Fighting the Flames at Salem, Mass.

This generic postcard was sold in numerous cities after major fires. Only the caption was changed to suit the location.

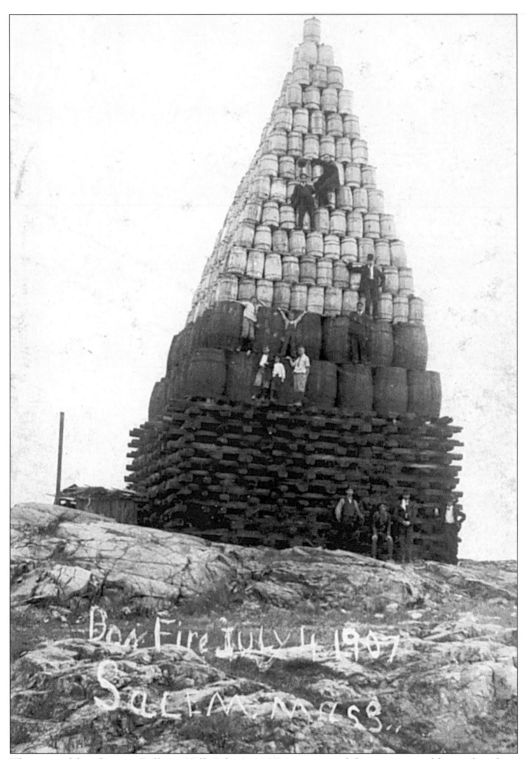

The annual bonfire on Gallows Hill, July 4, 1907, was ignited from an assemblage of timbers and old wooden barrels. Boys and young men pose on the precarious structure in triumph.

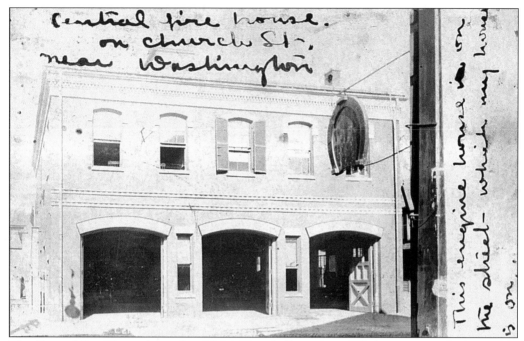

Central fire house.
on church St.,
near Washington

This engine house is on the street – which my home is on.

The Central Fire House, located at 30-34 Church Street, near Washington, was built in 1861 and appears in good condition in 1908.

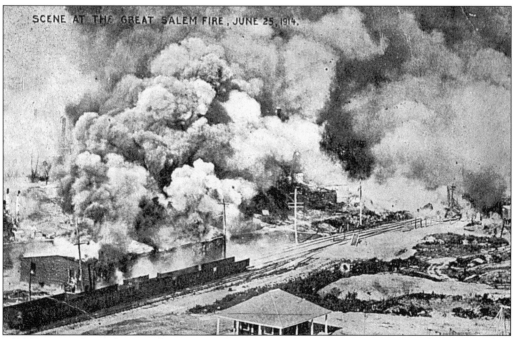

SCENE AT THE GREAT SALEM FIRE, JUNE 25, 1914.

The Great Salem Fire began in the early afternoon of June 25, 1914. It started at Blubber Hollow and consumed many acres. Firemen from 22 municipalities joined the effort to extinguish it.

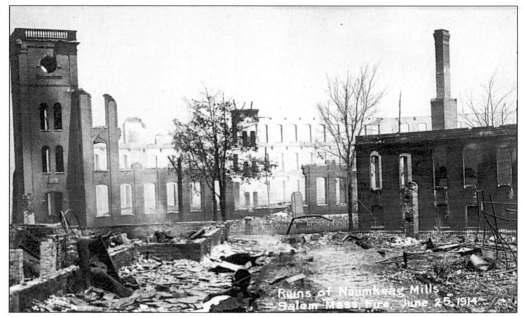

The Naumkeag Steam Cotton Company, built in 1845 on Congress Street, was completely destroyed by the blaze.

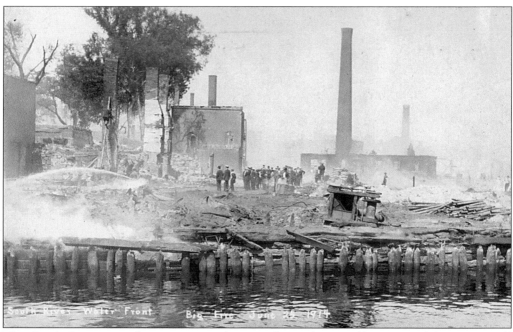

The South River waterfront area was devastated. Smoke is still rising and hoses are still working, but onlookers have arrived. Inexplicably, someone is climbing a pole leaning against a brick pier.

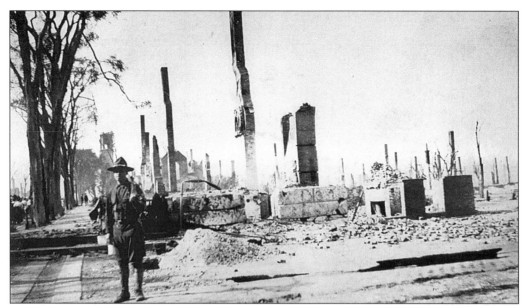

The National Guard was called out to keep order after the fire was extinguished. The upper card is Lafayette Street from Lagrange Street, with St. Joseph's Church in the background. The lower card is a view across Fairfield Street from Lafayette Street.

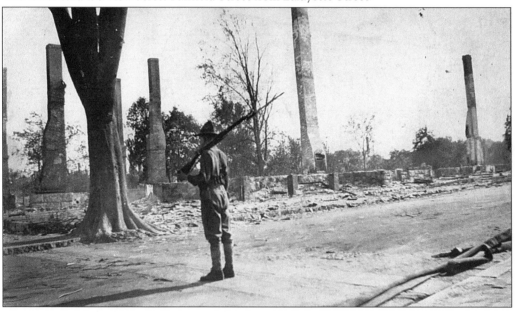

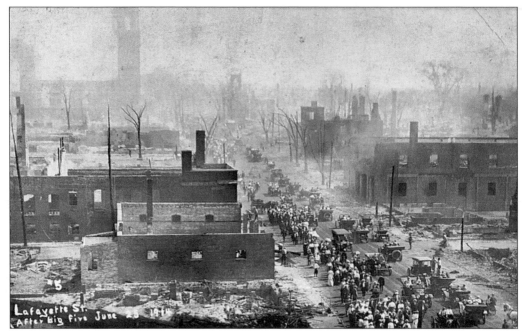

Even while the smoke was still in the air, a traffic jam was created by vehicles and pedestrians along Lafayette Street. Notice the towers of St. Joseph's Church in the upper left.

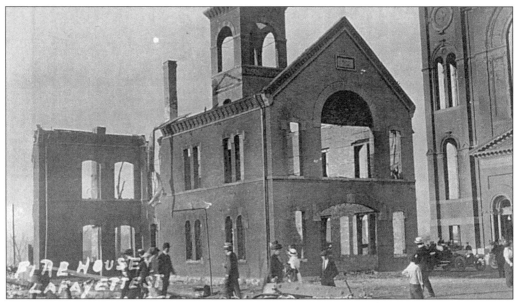

The brick firehouse at Lafayette and Washington Streets was in complete ruins. St. Joseph's Church is on the right.

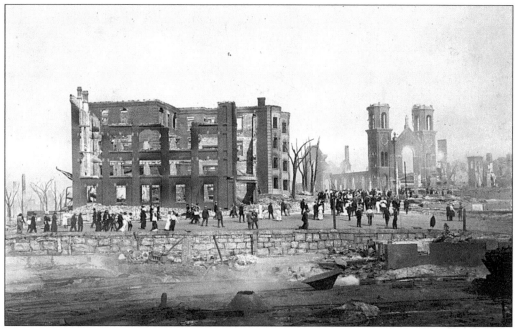

The upper card shows more onlookers at Mill Hill, with St. Joseph's to the right. The lower card shows a remarkably intact statue of St. Joseph looking down on the remnants of his church. This card was available for purchase and was postmarked July 1, 1914. The sender states, "I was greatly impressed with the noticeable good behavior and orderly manner of your family, all being so young and in such terrible confusion and mad rushing in the streets."

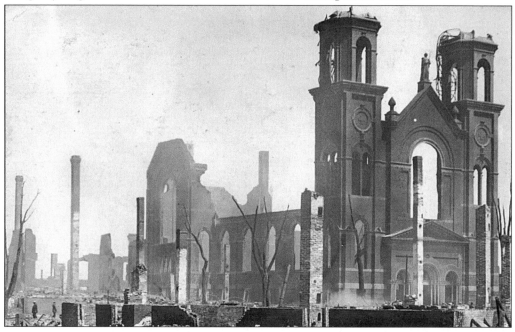

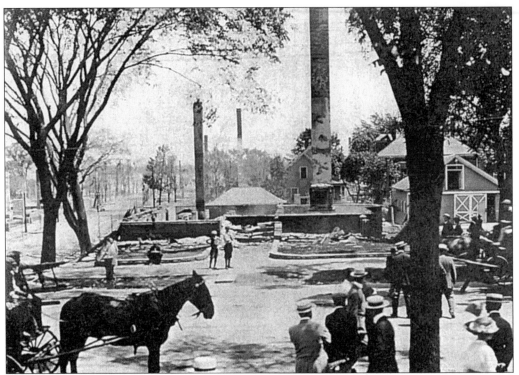

This real photo postcard view is at the perimeter of the fire at an unknown location. The message side reads "Where the fire ended." (Courtesy Nelson Dionne.)

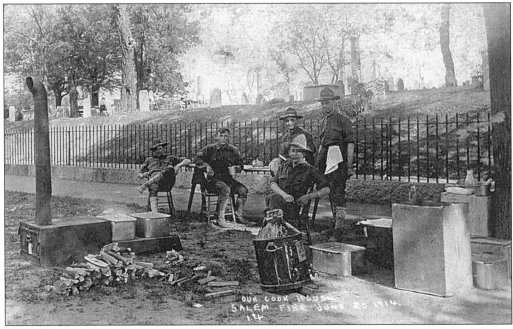

The National Guard had set up an emergency food preparation station at the Broad Street cemetery. A Guardsman may have taken the image since it is titled "Our Cook House." (Courtesy Nelson Dionne.)

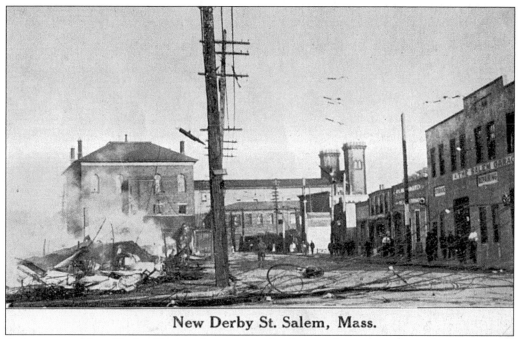

New Derby St. Salem, Mass.

As seen on New Derby Street, fires not only destroyed property but also interrupted communication and electrical service. A telephone pole has burned and the wires cascade across the street. The Salem Garage is on the right and the towers of the train depot in the distance.

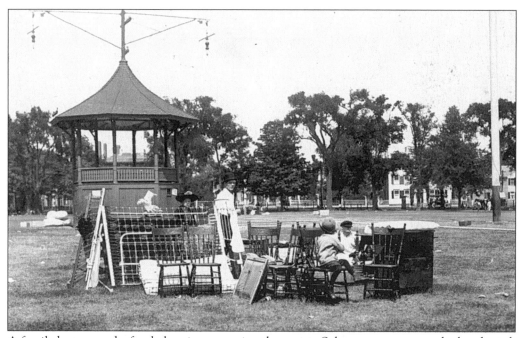

A family has rescued a few belongings, carrying them onto Salem common, near the bandstand. They were able to salvage some furniture, a couple of pictures, and, remarkably, a feathered hat.

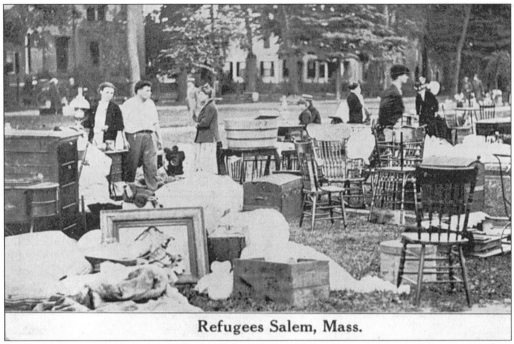

Refugees Salem, Mass.

What to us might look like a yard sale or flea market was to these refugees all they had left in the world.

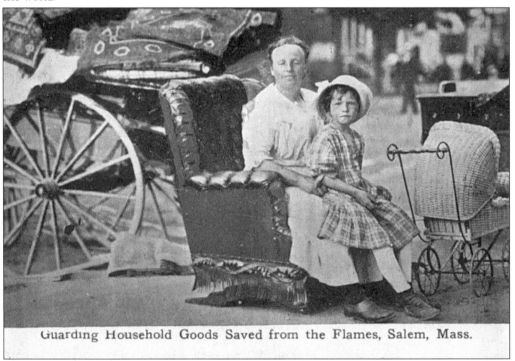

Guarding Household Goods Saved from the Flames, Salem, Mass.

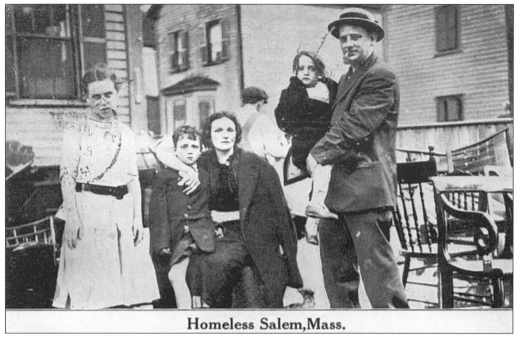

Homeless Salem, Mass.

The homeless also brought their belongings to the homes of friends and relatives in other parts of the city that were not burned.

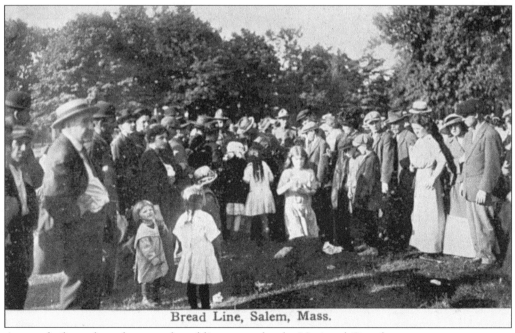

Bread Line, Salem, Mass.

A crowd of people gathers at a bread line set up by the National Guard.

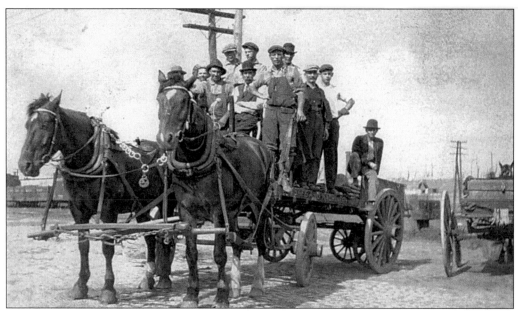

An unidentified dray wagon at the Salem railroad yard was likely being employed in the cleanup and rebuilding following the fire since the card was dated August 1914. (Courtesy Nelson Dionne.)

A house on Boston Street, at Proctor, although burned, was rebuilt and still exists at 65 Boston Street. The message reads, "Dear Father, this is a front view of the house where we lived before the big fire. I had these pictures taken myself." (Courtesy Nelson Dionne.)

Eight

THE WATERFRONT

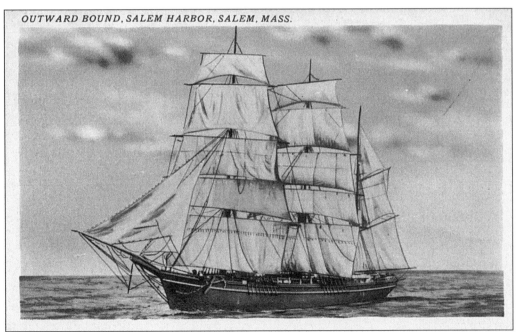

OUTWARD BOUND, SALEM HARBOR, SALEM, MASS.

A generic novelty card entitled "Outward Bound, Salem Harbor," was meant to evoke the heritage and coastal location of Salem. Ships such as the one depicted here were often seen in Salem Harbor.

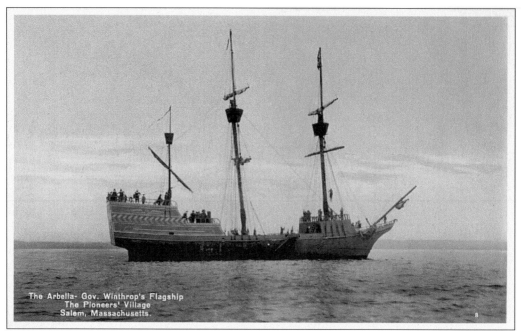

The *Arbella* was a recreation of Governor Winthrop's flagship. Originally the schooner *Lavolta*, it was purchased by the Massachusetts Bay Tercentenary Company, Inc., which altered it to resemble the ship of 1630. It entered Salem Harbor June 12, 1930, and was based at Pioneer Village.

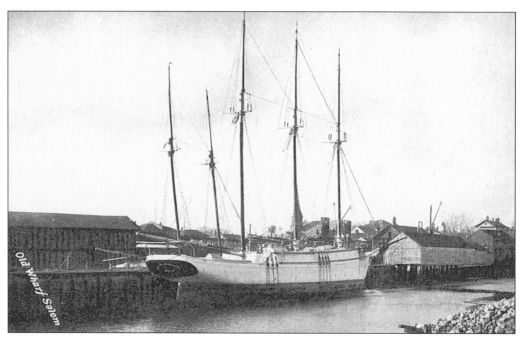

The old wharf in Salem, seen here shortly after 1900, still serviced schooners that could unload their cargo directly into the warehouses on the pier. The steeple of the Immaculate Conception Church is behind the second mast from the right.

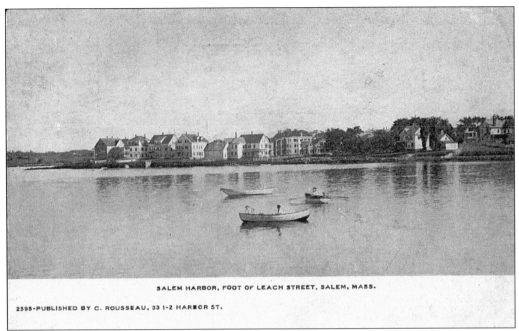

SALEM HARBOR, FOOT OF LEACH STREET, SALEM, MASS.

2595-PUBLISHED BY C. ROUSSEAU, 33 1-2 HARBOR ST.

Salem Harbor at the foot of Leach Street appears to be quite calm on a summer day, c. 1908. These boaters in Palmer's Cove are using dories for recreation, but they also worked boats in the fishing industry. Marblehead can be seen to the far left. The publisher of this rare card is Calixte Rousseau of Salem.

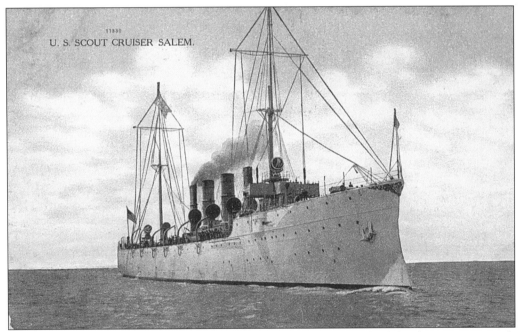

U. S. SCOUT CRUISER SALEM.

Salem is well known as a seafaring community. It was honored by the federal government with the naming of the U.S. Scout Cruiser *Salem*. This image is from 1911.

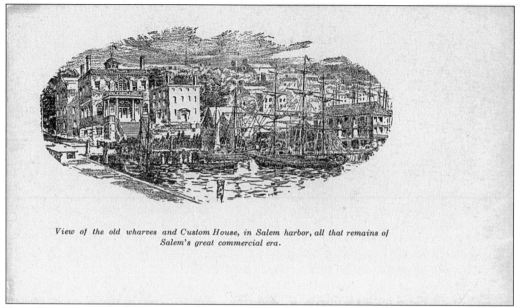

View of the old wharves and Custom House, in Salem harbor, all that remains of Salem's great commercial era.

A private mailing card (1898–1907) of the old wharves gives us an idea of how busy the port really was. The proximity of the Custom House assured the government its due since not much activity went unnoticed by officials.

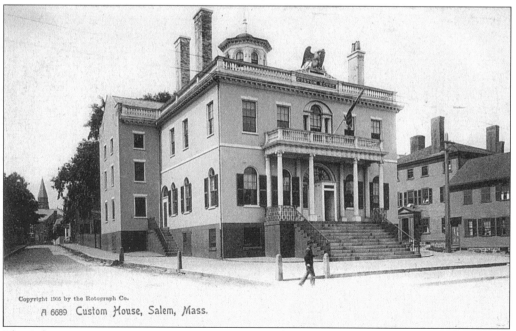

Copyright 1905 by the Rotograph Co.

A 6689 Custom House, Salem, Mass.

The Salem Custom House, built in 1818–19 at 178 Derby Street, is one of the finest examples of Federal-style public architecture in America. An excellent description of the building is in the introduction to *The Scarlet Letter* by Nathaniel Hawthorne; he was the surveyor of the port from 1846 to 1849. Also shown in this 1905 view, on the right, is the Benjamin Hawkes House.

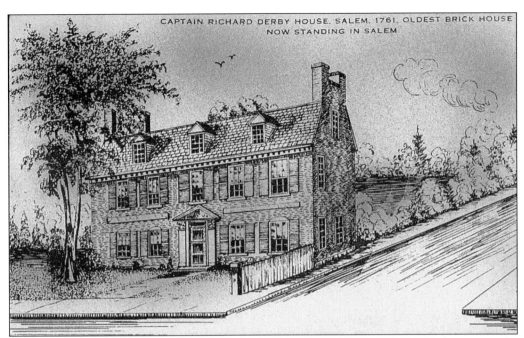

The Captain Richard Derby House at 168 Derby Street was built in 1761–62 by the captain for his son, Elias Hasket Derby, the first millionaire in America. This, the oldest brick house in America, was acquired by the Society for the Preservation of New England Antiquities in 1927 and turned over to the National Park Service in 1938. It is part of the Salem Maritime National Historic site.

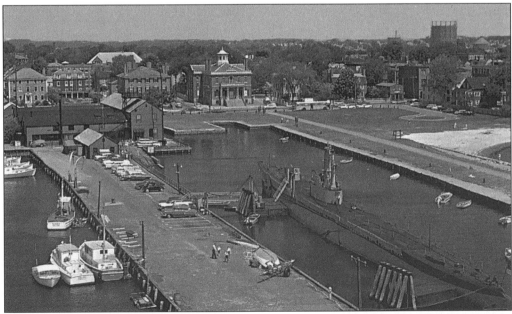

Central Wharf (left) was built by Simon Forrester in 1796. Derby Wharf (right) was begun in 1762 and reached its complete length in 1809. Both are part of the Salem Maritime National Historic Site. In the 1970s, Central Wharf was leased to the U.S. Navy and the submarine was open to the public.

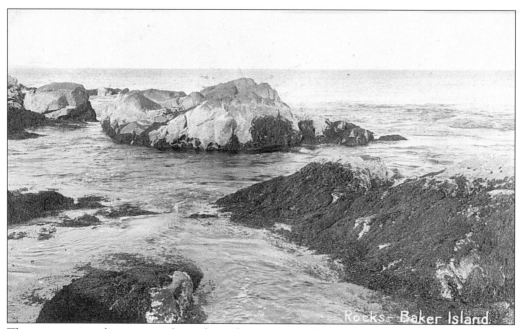

The picturesque location and soothing breezes of Baker's Island in Salem Harbor were appreciated. This card's message reads, "Got here all safe and sound. I was not sick. There are 20 of us. Having a fine time. It is 101 in Salem but cool here. 7/1/1913, Mother."

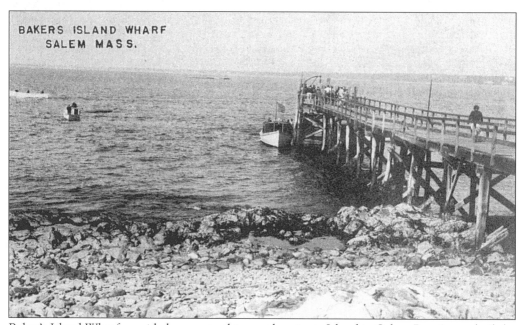

Baker's Island Wharf provided access to this mostly private Island in Salem Bay. It was built by George P. Woodbury, who summered here.

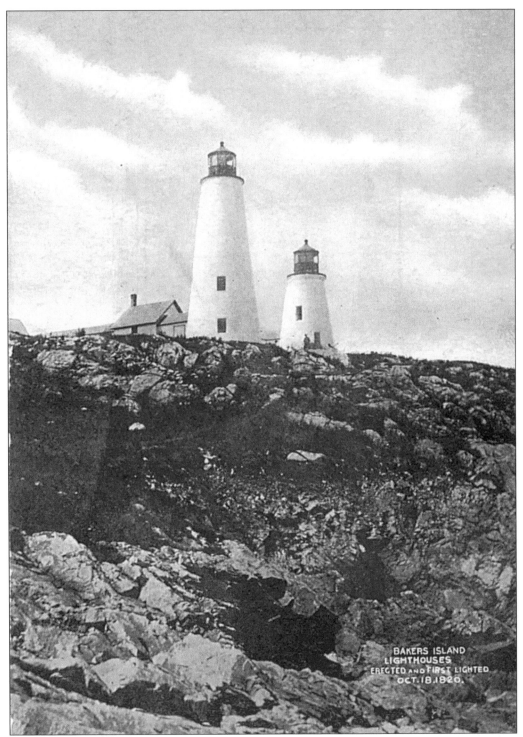

BAKERS ISLAND
LIGHTHOUSES
ERECTED and FIRST LIGHTED
OCT. 18, 1820.

The federal government owned the ten acres around these twin lighthouses on Baker's Island. "Ma and Pa Baker" were first lighted on October 18, 1820. The smaller one was later removed. This rocky outcropping developed into a summer community in the late 19th century.

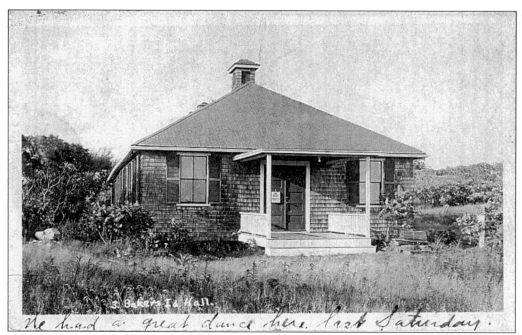

The Baker's Island Association was formed in 1914. The first order of business was to accept land donated by Mr. and Mrs. Charles W. Morse for building a meeting place. The Baker's Island Hall was completed for the 1914 season. The message reads, "We had a great dance here last Saturday." (Courtesy Nelson Dionne.)

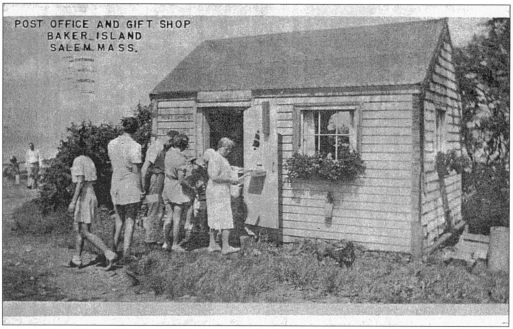

Baker's Island Post Office and Gift Shop served the many residents and visitors who rented cottages here. Many were privileged with sweeping views of Salem Sound. This card's message reads, "Dear Ethel, What a beautiful island, just the place for rest. Am enjoying every minute of it." (Courtesy Nelson Dionne.)

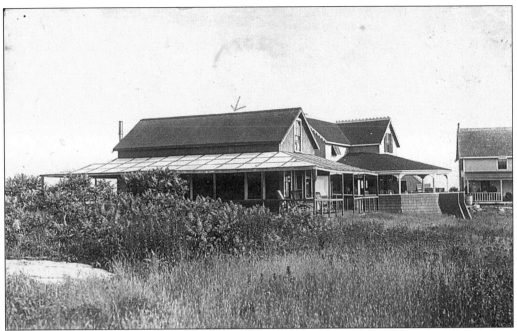

The Baker's Island cottages were simple affairs with very little decoration, but they were perfectly matched to their surroundings. In 1918, the major entertainment seems to be sitting on the generous porches, visiting with neighbors, and watching the changes in the sea and sky. The sender of this card writes, "Dear Mamma. . .It has been quite foggy and the surf is great. This is a picture of our cottage. . .With love, Buff."

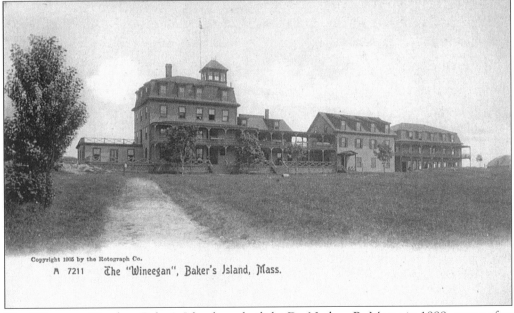

Copyright 1905 by the Rotograph Co.
A 7211 The "Wineegan", Baker's Island, Mass.

The Wineegan Hotel on Baker's Island was built by Dr. Nathan R. Morse in 1888, a year after he bought all but ten acres of the island. The hotel was constructed of wood and enlarged over the years. Its final form is documented on this card. Dr. Morse's "75 pleasant and well furnished rooms" were destroyed by fire on April 25, 1906.

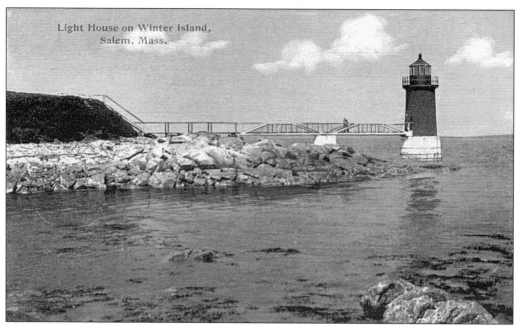

The Winter Island Lighthouse, built in 1871, is accessed by an unusual iron bridge walkway. For a time, this portion of the island served as a base for the U.S. Coast Guard.

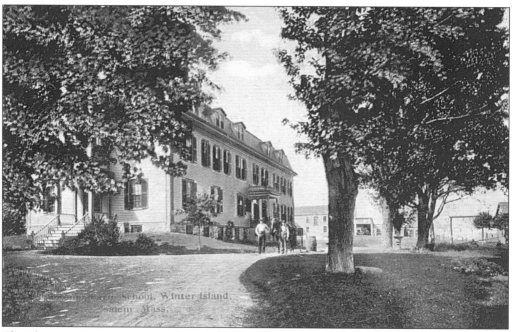

The Plummer Farm School on Winter Island opened in 1870. It was a reformatory for boys and gave the misbehaved a bit of training in agriculture—and a lot of old-fashioned farm discipline.

Nine
CEMETERIES AND PARKS

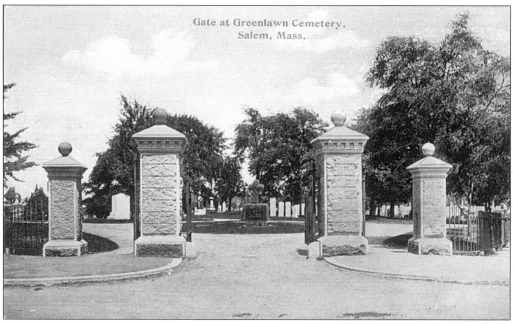

About two and one-half acres were purchased by the town in 1807 for use as the Orne Street Burying Ground. In 1864, another six acres, formerly a part of the Putnam estate, were added. Now known as Greenlawn Cemetery, visitors enter through the massive gateposts of the main entrance, shown here.

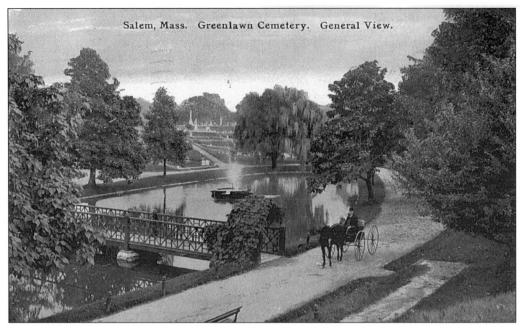

The contemplative scene presented on this postcard shows the dignified resting-place of many Salem families. Greenlawn Cemetery, bounded by Orne and Appleton Streets and Liberty Hill Avenue, opened in 1807.

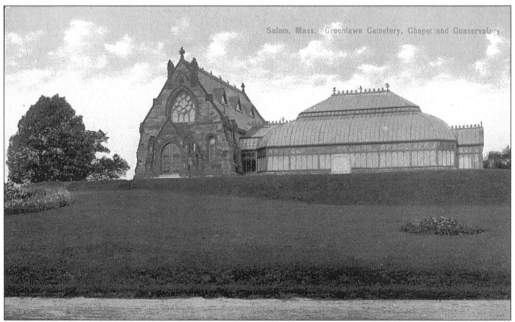

Greenlawn Cemetery's impressive Dickson Memorial Chapel and Conservatory were built in the High Victorian Gothic Revival style between 1892 and 1894. The architect for the buildings was George F. Meacham. The chapel was donated to the city in memory of Georgia Dickson by her husband Walter Dickson.

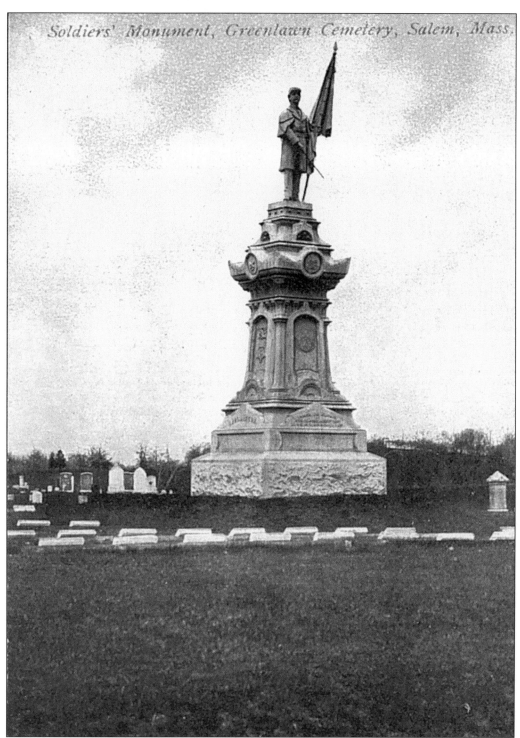

The Soldier's Monument in Greenlawn Cemetery commemorates the more than 200 Salem men who gave their lives in the Civil War, and 55 who died of disease. Over 3,000 Salem residents served in the nation's most devastating war.

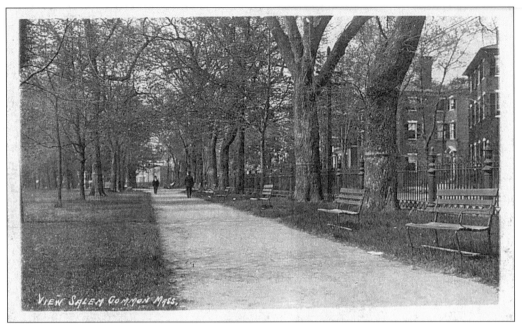

Salem Common, as seen in this early-20th-century postcard, continues to be a popular place to stroll or attend a band concert. The land has seen many changes; it once contained several ponds and swamps. Like a typical New England common in the colonial period, it was originally used for the grazing of livestock and for the training of militia. Beginning in 1801, through the efforts of Elias Hasket Derby Jr., the area was filled in, graded, trees and shrubs were planted, and walkways were added. A wooden fence with four gates that surrounded the land was replaced *c.* 1850 by the cast-iron fence seen in this card.

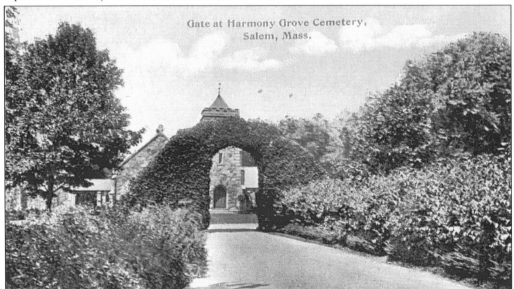

Harmony Grove, a private, non-denominational cemetery, was consecrated on June 14, 1840. Designed to look like an English landscape, it is the burial place of many of Salem's notable citizens. The Blake Memorial Chapel opened in 1905 and the Harmony Grove Crematory in 1917. Today the cemetery contains 98 acres.

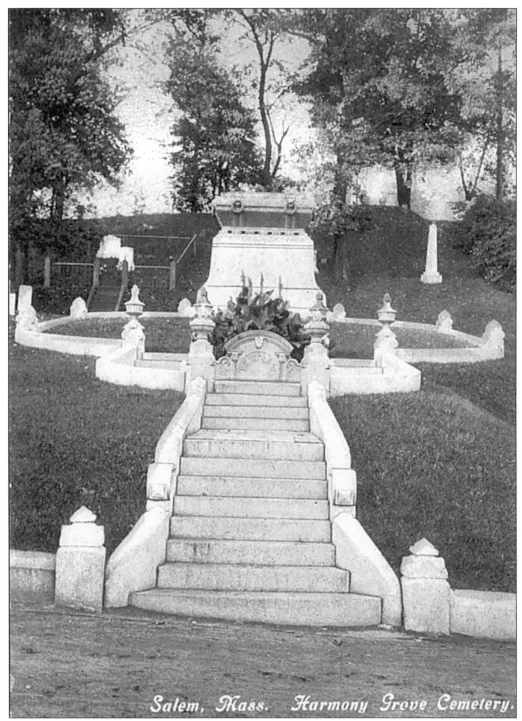

Salem, Mass. Harmony Grove Cemetery.

A large sarcophagus of granite marks the last resting place of Capt. John Bertram. A successful merchant and ship owner, Captain Bertram was considered "one of the richest men in Massachusetts." When he died in 1882 at age 86, he was remembered for his support of numerous charities.

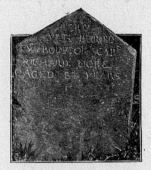

Salem, Mass., 190

Dear

I am not particularly fond of graveyards or gravestones, as you may know!— but I could not help being interested in this ancient stone, in the old burying ground here, which is over the grave of one of the first passengers in the Mayflower, and the only one of the Pilgrims on that voyage , whose gravestone is known to be in existence. It is carved out of a slate-like mineral, and is still in a fine state of preservation.

Published by the Salem Press Company, Salem, Mass.

The Charter Street Burying Ground, which dates to 1637, is the oldest cemetery in the city. The top card is a private mailing card, printed between 1901 and 1907, and features the gravestone of Richard More. It is the only known original grave marker of a Mayflower passenger. The bottom card (mislabeled "Charles" Street) gives an overview of the cemetery.

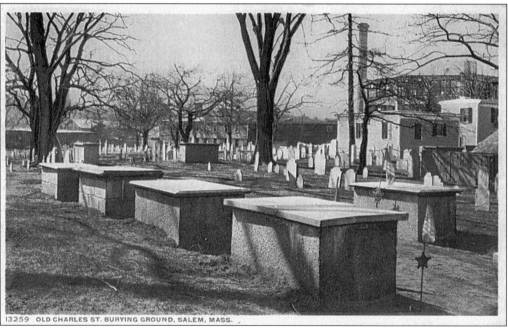

13259 OLD CHARLES ST. BURYING GROUND, SALEM, MASS.

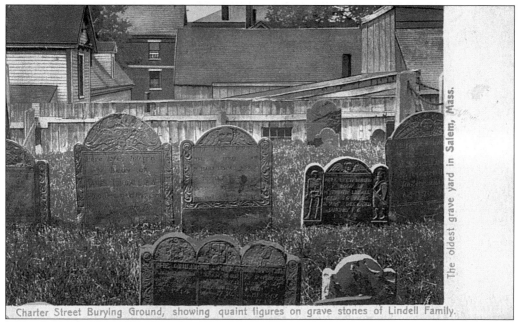

The oldest grave yard in Salem, Mass.

Charter Street Burying Ground, showing quaint figures on grave stones of Lindell Family.

Several gravestones of the Lindall family, located in the Charter Street Burying Ground, are seen in the center of this postcard. The winged skull and skeleton on the stones are typical 17th- and 18th-century images reminding man of his mortality.

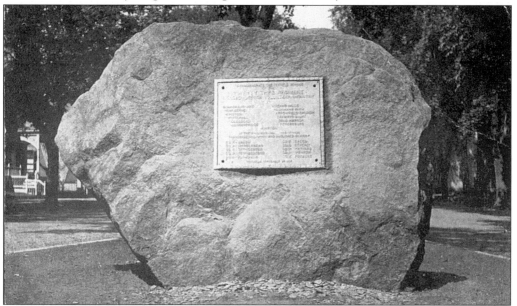

The 23rd Regiment of the Massachusetts Volunteer Infantry is commemorated on a plaque attached to this 58-ton boulder, which was brought to Winter Street from Salem Neck in 1905. The 23rd, during the Civil War, was composed mainly of Companies from Essex County. Many Salem men were mustered in during September of 1861 and remained with the companies until they were discharged in July of 1865. Over their period of service, the regiment was involved in numerous battles, including Roanoke Island, Newbern, and Cold Harbor with many men making the ultimate sacrifice.

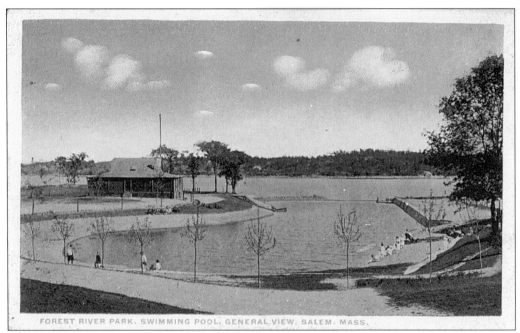

FOREST RIVER PARK. SWIMMING POOL. GENERAL VIEW. SALEM. MASS.

To meet the growing recreational needs of its citizens and tourists, the City of Salem opened Forest River Park along Salem Harbor in 1907. The pool and bathhouse were added in 1915 and, as the postcard shows, were immediate successes.

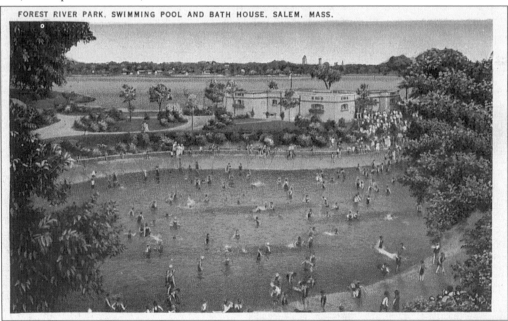

FOREST RIVER PARK, SWIMMING POOL AND BATH HOUSE, SALEM, MASS.

Ten

SALEM WILLOWS

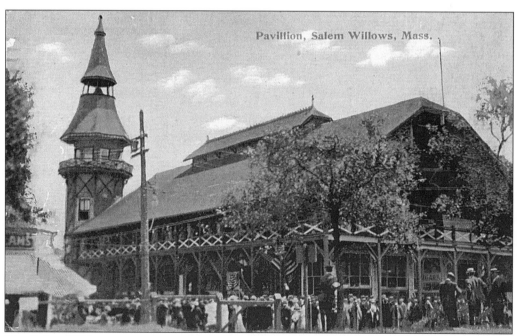

The Salem Willows amusement park still flourishes. The Pavilion once accommodated many diners. Here, a large crowd is seen surrounding the building, possibly awaiting tables. The Pavilion opened on June 10, 1880. At the left of this 1916 card is a sign for clams at Downing's Restaurant.

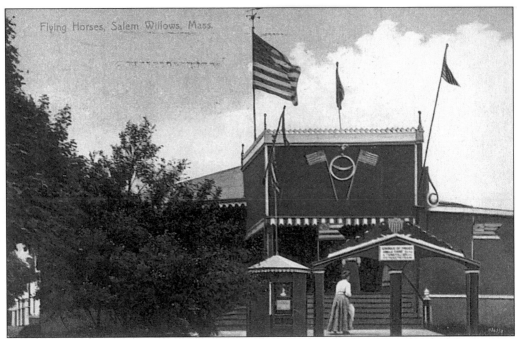

Brown's Flying Horses, as seen in this 1911 card, featured wooden horses carved by Joseph Brown, a Polish immigrant. This was later the site of a miniature railroad and the Tilt-a-Whirl, but it is now a vacant lot.

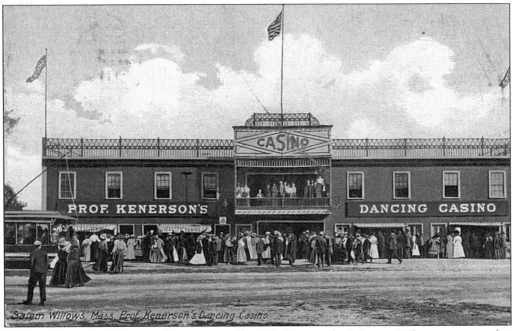

Professor Kenerson's Dancing Casino opened in July 1895 as the "Casino." The message on this 1909 card reads, "There is a lot of spooning here."

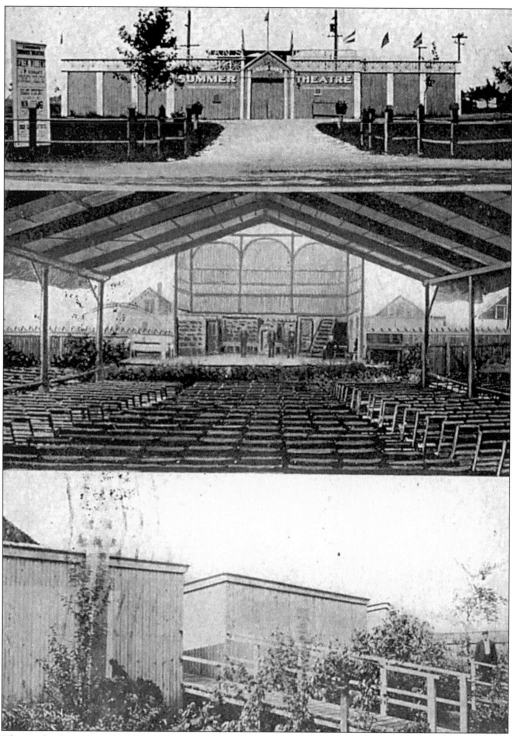

These three views of Gorman's "Summer Theatre" prove that Tanglewood is not a modern concept. The 1909 season promised "The brightest and best in Musical Comedies and Vaudeville's most charming features."

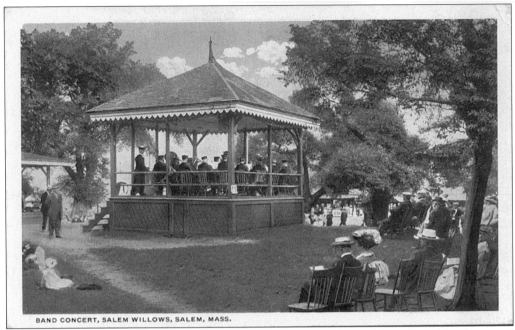

BAND CONCERT, SALEM WILLOWS, SALEM, MASS.

A concert at the bandstand in 1918 featured the Salem Cadet Band, conducted by the noted composer Jean M. Missud (1856–1941.) A native of Nice, France, Missud was acclaimed by John Philip Sousa as one of the most influential bandmasters in the country.

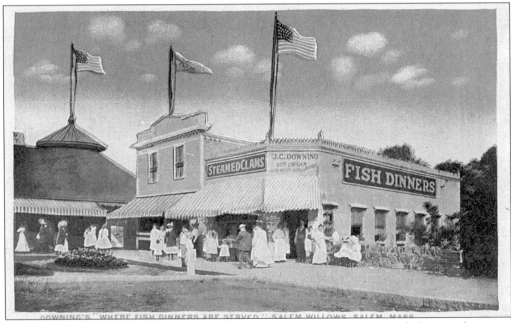

DOWNING'S "WHERE FISH DINNERS ARE SERVED" SALEM WILLOWS SALEM MASS.

Downing's Restaurant was famous as much for its fish dinners and steamed clams as for its ice cream. Many tourists sent postcards from the post office sub-station that operated there during the summer from 1908 to 1915. J.C. Downing retired after the 1922 season. Today the building houses Hobb's popcorn and ice cream concessions.

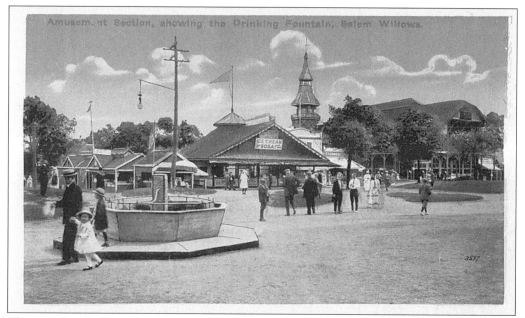

This popular drinking fountain in the amusement section of the Willows no longer exists. However, just to the right is Hobb's, which still sells ice cream and soda.

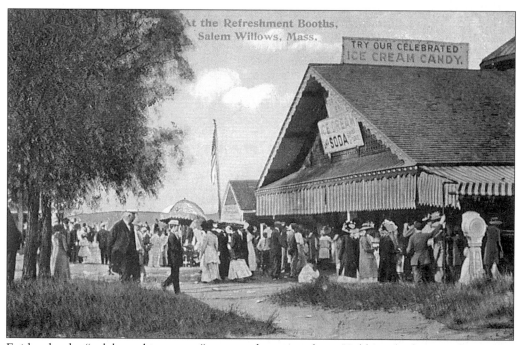

Evidently, the "celebrated ice cream" was worth waiting for at Hobb's, which opened in 1897.

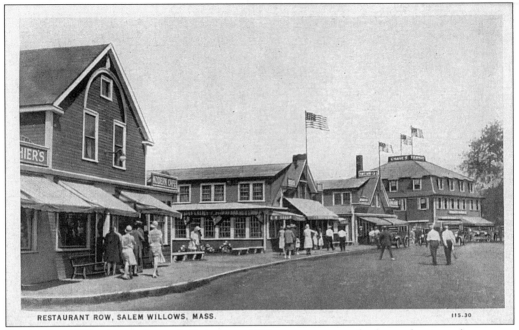

RESTAURANT ROW, SALEM WILLOWS, MASS. 115-30

Since the 1870s, a number of dining establishments operated along the area known as "Restaurant Row." Seafood was a specialty at Gauthier's Modern Café, Swenbeck's, and Chase's in this 1930 view. After several devastating fires, all of these buildings were razed.

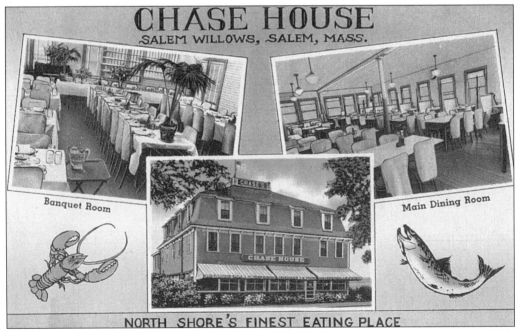

CHASE HOUSE
SALEM WILLOWS, SALEM, MASS.

Banquet Room

Main Dining Room

NORTH SHORE'S FINEST EATING PLACE

This Chase House advertising postcard claimed "Known from coast to coast. . .pioneers in fish dinners. . .and refreshing and cooling breezes from the ocean blow almost continuously." The restaurant was established in 1874 and closed in 1957.

126

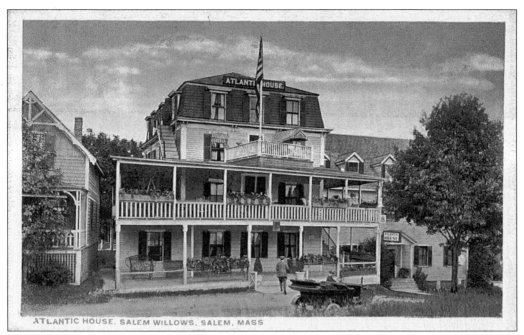

ATLANTIC HOUSE, SALEM WILLOWS, SALEM, MASS

The Atlantic House at 13 Harbor View was built in 1885 and continued as a busy summer hotel at Salem Willows until 1935.

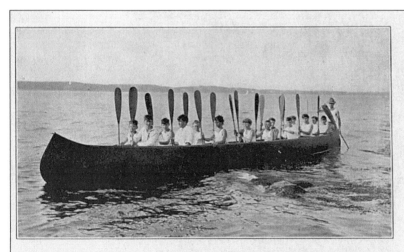

PRIVATE LAUNCH
DAILY

TO THE ISLAND CAMP
OF SALEM Y.M.C.A.

LAUNCH LEAVES REMON'S LANDING, SALEM WILLOWS, AT 10 A.M. RETURNING AT 5.30 P.M.

THE COST OF THE DAY'S OUTING INCLUDING DINNER IS 35 CENTS MANY PLAN TO STAY OVER NIGHT, RETURNING NEXT MORNING THE COST OF A DAY AND NIGHT AT CAMP IS 75 CENTS

The Salem YMCA operated an island camp in Salem Harbor and ran this private launch that the boys had to power themselves. The cost of a day's outing with dinner was 35¢. An overnight stay was 75¢.

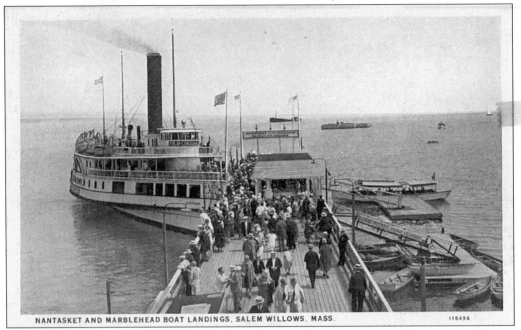

NANTASKET AND MARBLEHEAD BOAT LANDINGS, SALEM WILLOWS, MASS. 118496

The Nantasket and Marblehead boat landing accommodated arriving and departing visitors to the Salem Willows, as well as those seeking harbor and fishing excursions. Here, the *Old Colony* is arriving.

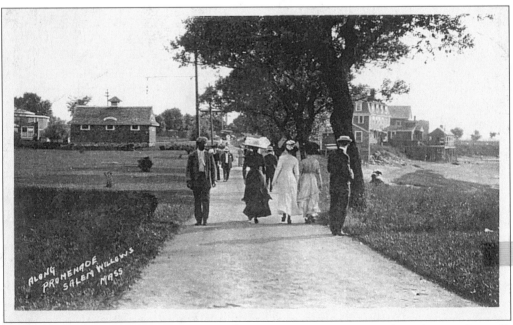

After a meal or too much excitement at the amusements, patrons might enjoy a quiet walk along the Promenade to appreciate the sea, sky, and shore life.

128